The Art and Mythology of
The Da Vinci Code

David M. Morris

Table of Contents

Acknowledgments v

Introduction vii

The Art and Mythology 1

 Leonardo da Vinci 3

 Le Jardin des Tuileries 5

 Opus Dei 9

 The Louvre and the Pyramid 11

 Pentacle or Pentagram 15

 Venus de Milo 17

 Vitruvian Man 19

 Notre Dame 21

 The Church of Saint-Sulpice 23

 Osiris 27

 Horus 29

 The Rose Line 31

 Mona Lisa 35

 Amon 36

 Isis 37

 Madonna of the Rocks 41

 Bois de Boulogne 43

 Knights Templar and the Priory of Sion 45

 Adoration of the Magi 47

 Dionysus 49

 Adonis 51

 The Last Supper 53

 The Holy Grail 55

 The Penitent Magdalen 57

 Shekinah 58

 Baphomet 59

 The Temple Church 61

 Rosslyn Chapel 63

 La Pyramide Inversée 67

Bibliography 69

Index 71

Acknowledgments

As every author knows, producing any work depends heavily on the efforts and energy of many others. This book is certainly no exception to that rule.

First, to Judith Thompson goes immeasurable gratitude for making this book happen! She allowed me to continue my peripatetic ways that are so much a part of my business and my life, while ensuring that the project stayed on track. Next I must acknowledge my longtime friend Lawrie Gervin, whose writing talents linked historical information about the images to the plot of *The Da Vinci Code*. I am extremely grateful for her long hours of hard work which gave real substance to my idea.

Also, I want to express sincerest thanks to those who helped by providing, or helping to secure, the photographs and images for this book. This process would have been impossible without the guidance and kind advice of certain individuals. In particular, I want to thank Stuart Beattie at the Rosslyn Chapel in Scotland for his patience in providing photographs of that edifice; the staff at the Metropolitan Museum of Art for providing a photograph of the work in their collection; Superstock for providing a wealth of art and images for our selection; Alamy for providing an image for our use; Stuart Isett Photography for providing all the photography on location in Paris and London; and Jonathan Morris for photography on location in New York. All of the images were reproduced with kind permission from their source.

Finally, heartfelt thanks to Shelley Sapyta, Kristen Butler, Ryan Feasel and all of the talented individuals at BookMasters for their willingness to work with us to meet our hectic deadline and their expert guidance in combining all these parts into a meaningful whole.

Introduction

The best-selling novel *The Da Vinci Code* has become a modern cultural phenomenon. No book in recent history has so completely captured the interest of such a wide range of the reading public. A few weeks after I finished the book, I was on an airline flight with a business associate who was reading my copy. Upon seeing the book, one of our flight attendants mentioned the fact that she had bought several art books that contained some of the works that were mentioned in *The Da Vinci Code*. That comment planted the seed in my mind, which, through a lot of hard work by a lot of good people, grew into this book.

Though it would be difficult for anyone to match the word-smithing talents of *The Da Vinci Code*'s author, I would suggest that the visual presentations in this work will significantly enhance the experience for the reader of *The Da Vinci Code*. Those readers who have read the work would, I believe, enjoy revisiting it using *The Art and Mythology of The Da Vinci Code* for a return trip through a modern classic. By using the books in parallel, not only will readers have the enjoyable experience of a fast-paced adventure story; they can also, at the same time, gain a deeper appreciation for the intriguing works and places that are the foundation of the tale. This book presents the photographs and images of the art and mythological references in the order that they are woven into the plot of *The Da Vinci Code*. I believe that being able to visualize these references makes the book come alive.

My friends and I put this book together more for fun than for profit, and, in that spirit, we have committed to contribute a part of our profit to scholarships for promising young writers.

The Art and Mythology

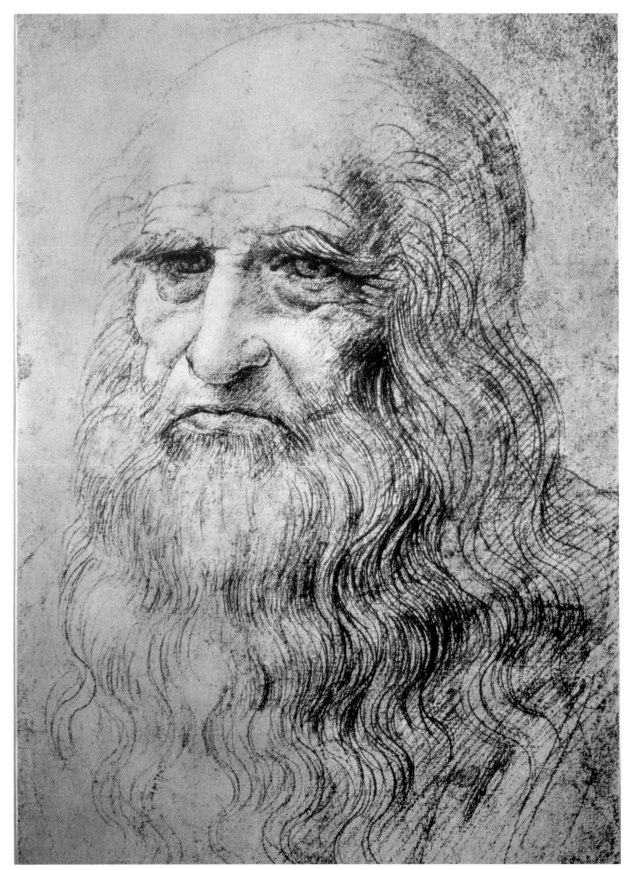

Self Portrait
Leonardo da Vinci (1452–1519/Italian)
ca.1512
Chalk and ink
Biblioteca Reale, Turin, Italy

Leonardo da Vinci

Born Leonardo di Ser Piero da Vinci, the man we know as Leonardo da Vinci was the son of a notary. He was born in Vinci near Florence, Italy on April 15, 1452 and died May 2, 1519. He was extraordinarily gifted and intelligent and was engaged in and contributed to the art, science and literature of his time. Most biographers divide Leonardo's life into three periods: Florentine (1469–1482); Milanese (1483–1499); and Nomadic (1500–1519).

During the Florentine period, Leonardo studied at Verrocchio's studio, which was a center of art in the city and the region. Leonardo was perfecting his style and craft during these years; he collaborated with others, including Verrocchio, the master painter to whom he was apprenticed One such collaboration was the *Baptism of Christ,* in which Leonardo painted the face of one of the angels holding Jesus' garments. His contribution to the painting is said to have lifted it from mediocrity. He had access during this time to the school of fine arts that was created by the Medicis, who were a noble family and patrons of the arts in Renaissance Italy. Although not much of his finished work exists from this period, drawings and sketches of women and children suggestive of his Madonnas do remain.

The Milanese period was spent in the service of Ludovico il Moro. It was during this time that Leonardo painted both versions of the *Virgin of the Rocks,* one of which now hangs in the Louvre and the other in the National Gallery in London. It was also during this period that he painted his most important work, *The Last Supper.* It took ten years of preparation, and manages to portray the full range of human emotion experienced at the moment when Christ announces that one of his followers will betray him. The face and expression of each individual in the painting is a study. Taken as a whole, the painting depicts numerous emotions and feelings flowing through the figures.

Also during this period, Leonardo worked for more than fifteen years on the equestrian statue depicting Ludovico il Moro and a bronze horse, which at the beginning of his service in Milan he had promised to provide to il Moro. In addition, during this period Leonardo indulged his talents and interest in scientific matters. However, because he was so secretive and kept his discoveries from public view, we do not know as much as we might about these endeavors. He wrote prolifically without publishing his writing, producing manuscripts in a kind of reverse writing that could only be read by using a mirror. One of the best ways that we see his scientific study is through innumerable sketches demonstrating his commitment to physical accuracy that is borne out in his paintings of things, people and animals. An invasion by the French in 1499 caused Ludovico's fall from power and ended Leonardo's employment.

From 1500 until 1516, Leonardo moved back and forth between Florence and Milan several times. In 1516 he accepted an invitation from King Francis I and went to France where he remained until his death in 1519. It was during this period that he painted the *Mona Lisa,* his famous study of a woman's face. Again, as in the *Last Supper,* his genius lies in his ability to portray a full range of human emotions.

Leonardo da Vinci died in France at the age of 67. Whether he died a Christian is debated. He certainly accommodated Christianity in his art.

Dan Brown, author of *The Da Vinci Code,* would have us believe that Leonardo was indeed a Christian, if not always conforming to the traditional Roman version of Christianity. Brown depicts him as a former Grand Master of the Priory of Sion and seeker of the sacred feminine.

❖ ❖

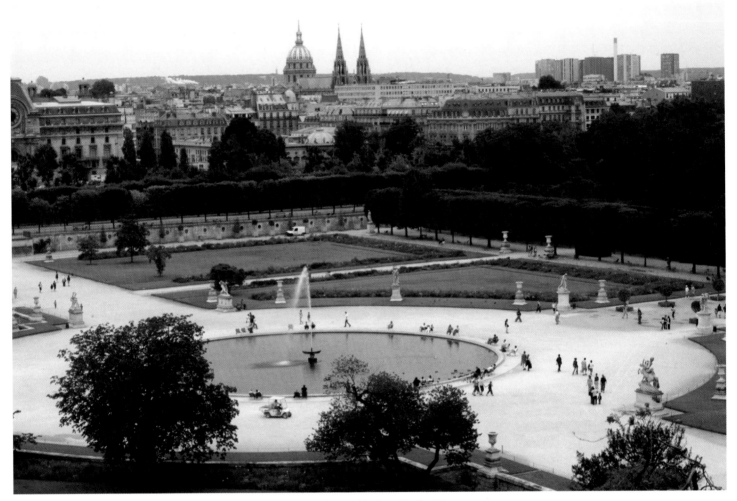

Le Jardin des Tuileries, Paris, France
Stuart Isett Photography, 2004

Le Jardin des Tuileries

The Tuileries Palace was begun in 1564 by Catherine de' Medici. It was home to Louis XIV while Versailles was built and was used primarily as a theater after that. Louis XVI was forced to live there during the Revolution. It was Napoleon's primary residence and he restored and redecorated the palace. In 1871 it was attacked by members of the Paris Commune and destroyed by fire. The palace was never rebuilt, but the gardens remain.

The gardens of the Tuileries cover approximately 63 acres. They were designed in 1664 by Andre Le Notre who was Louis XIV's gardener and who also designed the gardens at Versailles. The gardens are spacious and formal. They contain paths, trees, reflecting pools, fountains and statuary. Eighteen bronze statues by Maillol were added in 1964 and 1965. The gardens are surrounded by Paris landmarks. The Louvre forms the eastern border of the Tuileries. The Seine forms the southern border. The Place de la Concorde is to the west and the Rue de Rivoli is to the north. A smaller museum of contemporary art, the Galerie Nationale du Jeu de Paume, is located in the northwest corner of the Tuileries. Also within the Tuileries is the Arc di Triomphe du Carrousel, a monument to Napoleon's victory at Austerlitz.

Le Jardin des Tuileries, Paris, France
Stuart Isett Photography, 2004

In pleasant weather, the garden is filled with both Parisians and tourists enjoying the views and strolling the pathways. Its location in a historical and upscale neighborhood with luxury shops, boutiques and museums explains its popularity.

The Jardin des Tuileries is mentioned near the beginning of *The Da Vinci Code* as Robert Langdon is being driven to the Louvre by a member of the Judicial Police. According to Dan Brown, four of the finest art museums in the world can be seen from the Tuileries: the Musée d'Orsay, the Pompidou Center, the Musée du Jeu de Paume and the Louvre. (Page 17.)

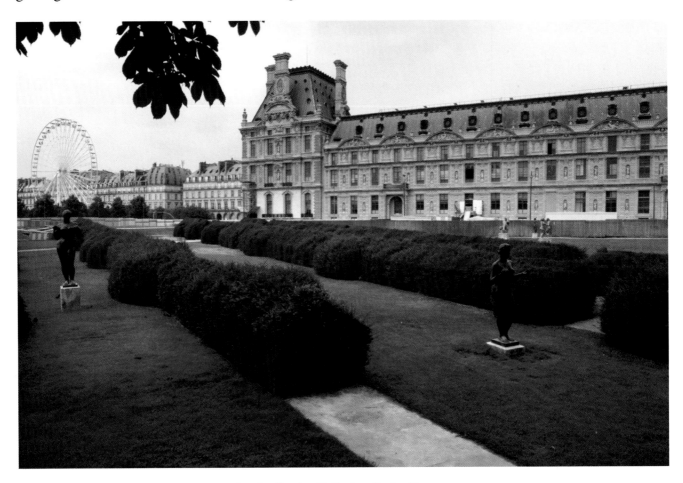

Le Jardin des Tuileries, Paris, France
Stuart Isett Photography, 2004

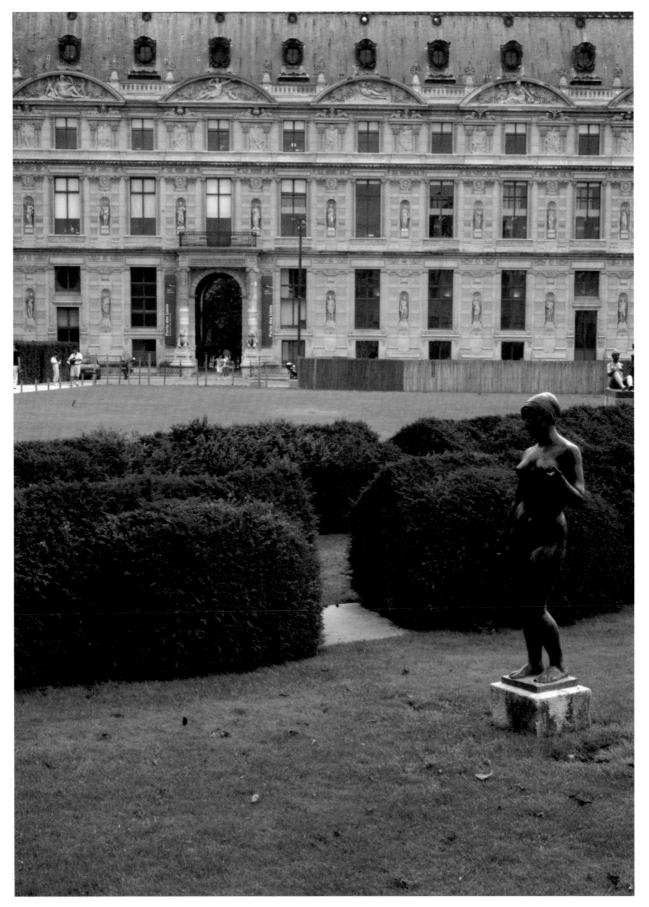

Le Jardin des Tuiliries, Paris, France
Stuart Isett Photography, 2004

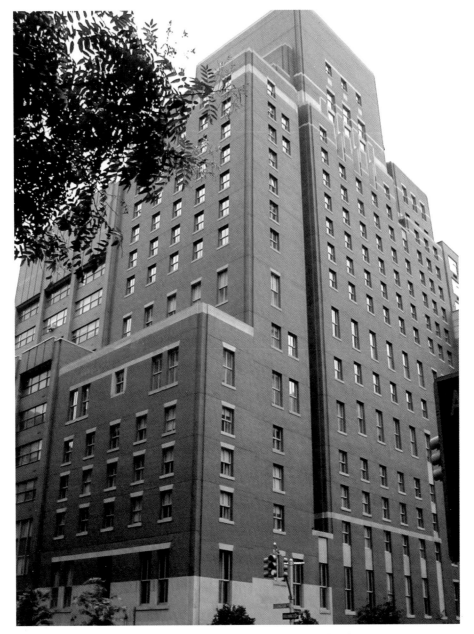

Opus Dei Building, New York, New York
Jonathan Morris Photography, 2004

Opus Dei

Opus Dei was founded by a Spanish priest, Josemaria Escriva de Balanguer, in 1928. Escriva was a prolific writer best known for his book *The Way,* which is a collection of maxims that address Christian life. His message was for the laity, encouraging everyday people to strive for spiritual consciousness in their everyday lives. According to Opus Dei, everyday activities can be made holy by offering them to God.

The movement grew from Spain to Europe to Latin America and to the United States. In 1982 Pope John Paul II bestowed the status of "personal prelature" on Opus Dei. This is a canonical term that grants jurisdiction over the individuals in Opus Dei, not over a geographic region, and allows it to oper-

ate as a religious order. The mystery is why Pope John Paul granted this status to a lay organization. Opus Dei operates in over 80 countries and has several thousand members in the United States. Father Escriva died in 1975 and was beatified in 1992.

In the United States Opus Dei has centers, or residences, for members in cities all over the country, often near college campuses. It claims some 3,000 members in the United States and some 85,000 worldwide. It sponsors outreach programs, retreat houses, high schools and conference centers.

Opus Dei presents itself as a lay institution of individuals who work in a variety of jobs and occupations. There are also priests and a hierarchy of other quasi-religious commitments that are held by both married and single lay people. The majority of members live secular lives in their own homes. For those who live in the centers, men and women live segregated lives.

Members will describe Opus Dei as an organization that encourages and supports them to consistently live their faith in ordinary circumstances and to cooperate in a sometimes hostile world in trying to alleviate society's problems through a Christian hermeneutic.

Critics will describe Opus Dei as a secret society that denigrates women and encourages self-denial and self-flagellation. But even critics will admit that Dan Brown's treatment of the organization in his book *The Da Vinci Code* is overly harsh. His villain is a member of Opus Dei who commits murder to destroy an organization, the Priory of Sion, that Opus Dei believes is antithetical to Christianity. His plot continues with the intrigue of a murder mystery and the revelation of the beliefs of the Priory of Sion regarding the sacred feminine. (Pages 12–14; 28–31; 40–42; 54–59; 73–74; 148–151; 166–167; 173–175; 195–196; 212; 251–252; 383–384; 388; 293–394; 414–418.)

Detail of Opus Dei Building, New York, New York
Jonathan Morris Photography, 2004

❖ 10 ❖

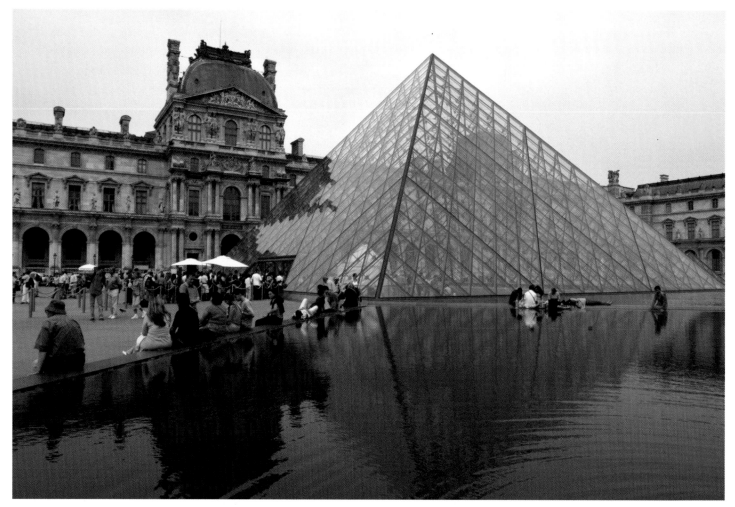

Musée du Louvre, Paris, France
Stuart Isett Photography, 2004

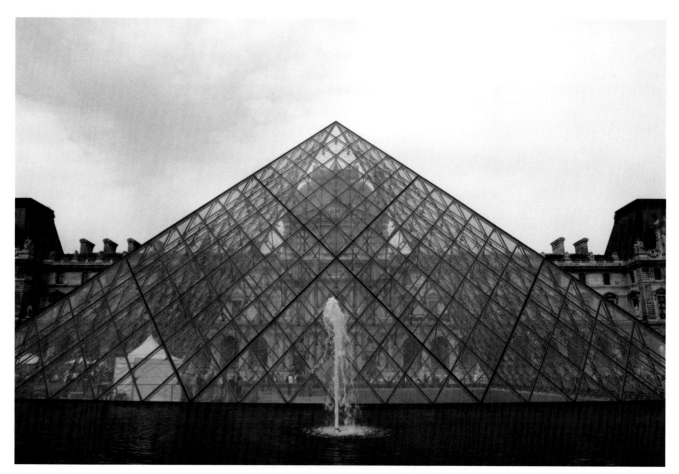

Glass Pyramid, Musée du Louvre, Paris, France
Stuart Isett Photography, 2004

The Louvre and the Pyramid

Originally the palace of the kings of France, the Louvre is probably the most famous museum in the world. It is located in the heart of Paris on the right bank of the Seine and is home to some 300,000 works of art. Some of its most famous residents are the *Mona Lisa,* the *Venus de Milo* and *Winged Victory.*

The public first was allowed in the Palace to view the king's art collection during the French Revolution. Before that time the collections housed within its galleries were viewed only by a privileged few. It was officially established as a museum in 1793 by the French Republic and is one of the oldest museums in Europe.

The Louvre was built in stages. The first part of the Palace as we know it was begun in the mid 1500s. Architecturally it had both French and Italian characteristics. Over the next 300 years it was extended progressively along the Right Bank. It divides the northern and southern parts of the city and is the east end of the Grand Perspective: The Jardin des Tuileries, the Place de la Concorde, the Arc de Triomphe and the Champs-Elysees.

The last renovation came at the end of the twentieth century as part of the Grand Travaux, or major works, commissioned by the then president of the Republic, Francois Mitterand. The architect and designer of the renovations was Sino-American architect I. M. Pei. Pei was born in China in 1917 but studied architecture at both MIT and Harvard. He taught at Harvard before joining the firm of Webb & Knapp in New York

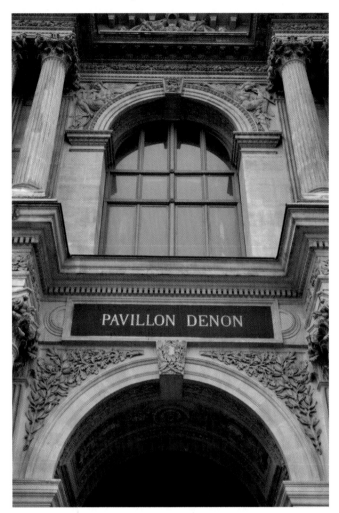

Detail of Musée du Louvre, Pavillon Denon, Paris, France
Stuart Isett Photography, 2004

in 1948. He founded his own firm in New York in 1960. Pei is known for his use of abstract design. Steel and glass, geometric shapes, and sophisticated high tech offerings are his trademark. Other buildings by Pei include the Rock and Roll Hall of Fame in Cleveland, Ohio; the National Center for Atmospheric Research, near Boulder, Colorado; the Johnson Museum of Art in Ithaca, New York; the Javits Convention Center in New York, New York; Hancock Place in Boston, Massachusetts; and the Everson Museum of Art in Syracuse, New York.

A steel and glass pyramid, highly controversial when first built, marks the entrance to the new museum and allows the sunlight to come in on the floor of an underground chamber that was hollowed out under its plaza and connects to underground corridors running to various wings of the museum. The above-ground dramatic pyramid is supported by intricate steel connections and rods.

The vast majority of the first 134 pages of *The Da Vinci Code* takes place in the Louvre. Jacques Sauniere, the Curator of the Louvre, is murdered in the museum. His granddaughter Sophie, a cryptologist with the Judicial Police, aligns herself with the protagonist, Robert Langdon, in this stage of the book. Through flashbacks on her relationship with her grandfather and explanations to Langdon, she manages to reveal her grandfather's intelligence and penchant for puzzles and riddles. She describes her childhood training with her grandfather as she herself deciphers some of the clues he has left for her and Langdon. This is the launching pad for the rest of the book—an attempt to find Sauniere's murderer and discover the Holy Grail. (Pages 17–27; 32–39; 43–53; 62–72; 78–87; 91–104; 108–114; 118–121; 124–126; 130–134; 452–454.)

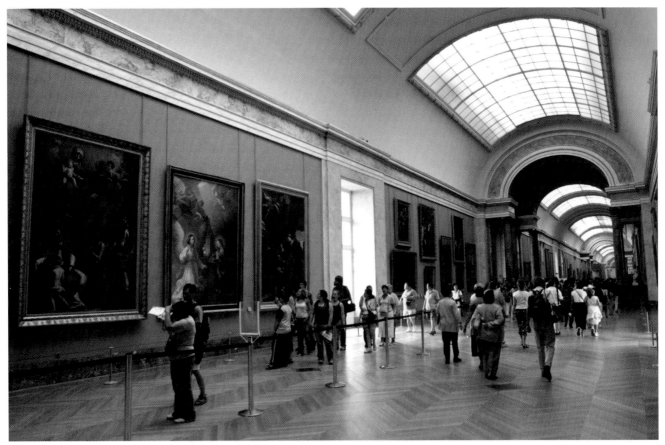

Interior Galleries, Musée du Louvre, Paris, France
Stuart Isett Photography, 2004

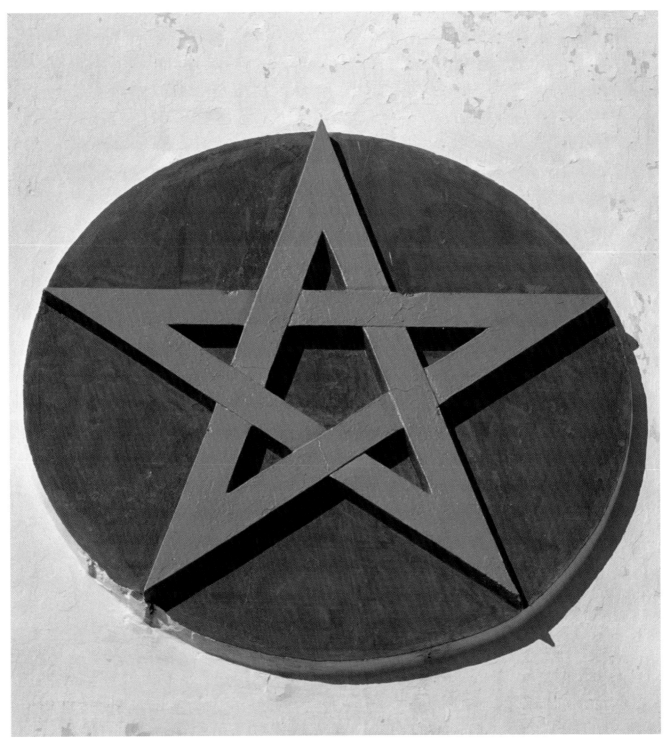

Detail of a Pentacle
AA World Travel Library/Alamy

Pentacle or Pentagram

The terms *pentagram* and *pentacle* are often used interchangeably. The technical difference in meaning seems to vary depending on the source or authority one selects. Generally, a pentagram is described as a five-pointed star. An upright pentagram is a five-pointed star with one point aligned upward, while an inverted pentagram is a five-pointed star with two points aligned upwards. A pentacle may be described as an upright pentagram surrounded by a circle. Webster's Dictionary, Eleventh Edition, does not differentiate between the pentagram and the pentacle, defining both as five pointed stars with points connected by a continuous line. Webster's also defines a pentagram as a "similar 6–pointed star [as a Solomon's Seal]."

The symbol has had different meanings for different cultures over time. For Christians, it has represented the five wounds of Christ, been referred to as the Star of Bethlehem, been called the Three Kings' Star, and was used in the past as a protective symbol or shield. The Roman Emperor Constantine was said to have used the pentagram in his seal.

From an occult perspective, upright pentacles represent good magic and are often used as talisman.

The inverted pentacle has come to be associated with Satanists. This symbol is often shown as the head of a goat within the pentagram. This inverted pentacle with a goat's head has a name of its own and is called the Sign of Baphomet. It has also been called the Devil's Goat and Judas Goat. Baphomet is referred to in documents from the Christian Inquisition during the interrogation of members of the Knights Templar, but it is not clear whether it was a statue or a reference to the Inquisition's torture methods.

In *The Da Vinci Code* the murder victim, Jacques Sauniere, uses his own blood to draw a pentacle centered on his navel. The protagonist, Robert Langdon, first explains that the pentacle is a pagan religious symbol. When this is taken to be synonymous with devil worship, Langdon goes on to explain that the pentacle is not necessarily a symbol for devil worship. He describes it as a pre-Christian symbol that relates to Nature worship. According to Langdon, the pentacle was representative of the female half of all things—the sacred feminine. Also according to Langdon, the pentacle was used to represent the goddess Venus, which to the ancients was symbolized by the planet with the same name. Observing the phenomenon of the planet tracing a perfect pentacle across the ecliptic sky every eight years, the ancients recognized the symbol as representing "perfection, beauty, and the cyclic qualities of sexual love." The Greeks organized their Olympic games on this cycle. Although Langdon acknowledges that the symbol has come to be seen as a satanic or demonic symbol, he stresses its other meanings. He uses it to comment on the fact that the early Christian church was competing with other existing religions and traditions and that one way to overpower them was to demonize their symbols. He also points out the fact that the U.S. military uses the pentacle as a symbol of war. That is, they paint it on fighter jets and hang it on the shoulders of generals. (Pages 35–37.)

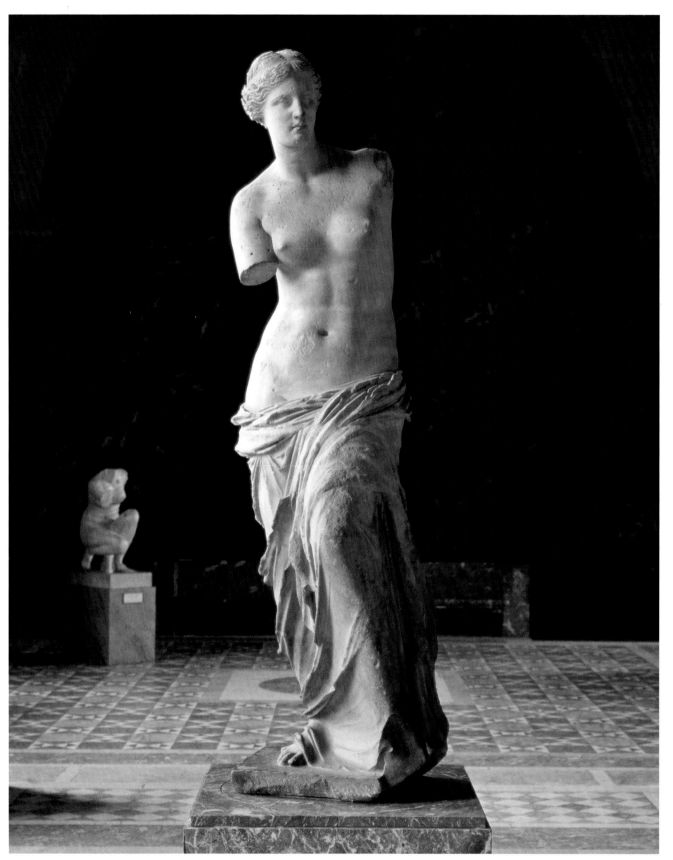

Aphrodite of Melos (*Venus de Milo*)
150 B.C.
Greek Art
Marble Sculpture
Musée du Louvre, Paris

Venus de Milo

Aphrodite of Melos (*Venus de Milo*)
150 B.C.,
Greek Art
Marble
Musée du Louvre, Paris

The statue known as the *Venus de Milo* (Roman) or the *Aphrodite of Melos* (Greek) dates from approximately 150 BCE. The sculptor is unknown. This figure representing the goddess of love and beauty is made of parian marble and stands six feet, ten inches tall (203 cm). An example of the larger-than-life style of Hellenistic sculpture, it currently is housed in The Louvre, Paris.

The work was found on the island of Melos in 1820 and shipped to France. Initially, attempts were made to reconstruct the missing arms. Finally King Louis XVIII, fearing that the elegance and beauty of the existing figure would be damaged, decreed that these attempts should cease and she was left in the form we see her today. Possession of a work of art from the classical Greek period was a status symbol in the world of art and politics at the time of the discovery. Therefore, France initially asserted that the figure dated from that time period. Controversy continued for many years over whether the figure dated from the period of classical Greek art or the Hellenistic period. Since the early twentieth century, it has generally been thought that the work is from the Hellenistic period.

Instantly recognizable because of the missing arms, she is one of the most famous works of art in the world today. She epitomizes elegance and grace with her dreamy look, twisting pose and sensual drapery.

Brown's protagonist alludes to Venus in explaining the pentacle drawn by Sauniere as he is dying. He provides a brief summary of the various religious representations of the sacred feminine. (Pages 36–37.)

Proportions of the Human Figure (*Vitruvian Man*)
ca. 1485–1490
Leonardo da Vinci (1452–1519/Italian)
Pen and ink
Galleria dell' Accademia, Venice

Vitruvian Man

Leonardo da Vinci's *Vitruvian Man* is a drawing of the ideal male figure. Created around 1490, it is an ink drawing approximately 13 1/2 by 9 1/2 inches and it currently hangs in the Galleria dell'Accademia, Venice.

Throughout history, artists have turned to mathematics to determine proportion when representing the human form. One such architect and engineer was Marcus Vitruvius Pollio, author of a ten-volume treatise on architecture in first-century BCE Rome. He wrote and believed that the circumference of a circle formed by placing a compass on a man's navel should touch the man's fingers and toes. According to Vitruvius not only did the spread-eagled form create a circle, it would also form a square. He believed that the distance from the soles of the feet to the top of the head would equal the distance of the outstretched arms, forming a square.

Likewise, Leonardo da Vinci believed the ideal man was defined by geometric or mathematical forms, such as circles and squares. Leonardo was a student of Vitruvius' theories and applied them in his drawing of the *Vitruvian Man*. He also devoted a great deal of time to the study of both science and engineering and applied this knowledge when drawing human figures. When it came to anatomy, both accuracy and proportion were important to him. The drawing is an example of Leonardo's interest in anatomy as well his commitment to scientific accuracy.

Early in *The Da Vinci Code* Dan Brown uses the symbolism of the *Vitruvian Man* to lead into a discussion of Leonardo's eccentricities. He has the victim in the book enclose himself in a circle drawn with a black light pen and position himself so that he will be found naked with his body, arms and legs mimicking the position of the man in Leonardo's famous drawing. It is only when the body is viewed with a black light that one can see the circle left by Jacques Sauniere, the murdered curator of the Louvre Museum. According to Brown, Leonardo was a homosexual and a "worshiper of Nature's divine order." Brown comments that the artist is perceived by some to have been interested in the darker, and even demonic, arts. He allegedly dug up corpses to study the human form.

According to Brown, Leonardo was frequently at odds with the Christian church although he often painted Christian themes in works commissioned by the Vatican. He was known for incorporating sometimes irreverent, at least as far as the Christian church was concerned, symbolism into his paintings. The protagonist in Brown's book, Robert Langdon, uses this discussion to comment that Jacques Sauniere, the victim, and Leonardo shared certain theological concepts, including the belief in the sacred feminine. Langdon comments that one common belief that they appeared to share was the idea that the sacred feminine had been eliminated from modern Christianity. This discussion provides the foundation for the elements of this spiritual ideology to be woven into the plot of the book. (Pages 44–46.)

Brown continues to use the *Vitruvian Man* reference to pull another character into the limelight. Sauniere's granddaughter, who works for the Cryptology Department of the Judicial Police, aligns herself with Langdon, declaring that the *Vitruvian Man* was her favorite Leonardo work and that her grandfather used it to bring her into the case and to catch her attention. (Page 69.)

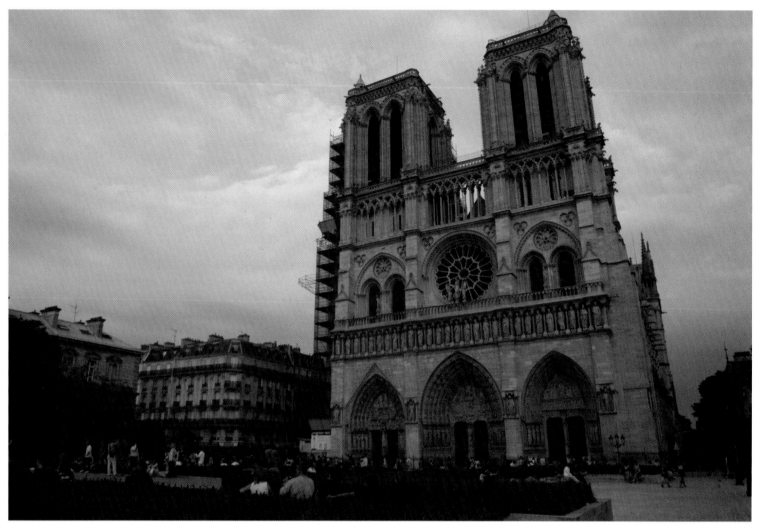

Notre Dame, Paris, France
Stuart Isett Photography, 2004

Notre Dame

The cathedral of Notre Dame is located on an island, the Ile de la Cité, in the center of Paris. Named for the Virgin Mary, some historians say that it was one of two churches originally on the site, one to the Virgin and the other to St. Stephen. It is recognized as probably the most famous example of the "new" gothic architecture of the twelfth century CE. Begun in 1163, Notre Dame was not completely finished until 1345. Its altar was dedicated in 1183. The nave was completed around 1208 and the famous west front towers were completed around 1235 to 1250. The original transept was completed around 1267. Notre Dame had the first flying buttresses, an architectural construct that was used to support the walls of the building.

The site had been host to other religious structures over time. The Romans built a temple to Jupiter there and in the sixth century Christians built a basilica on the site. The last edifice to occupy the site before Notre Dame was a Romanesque church.

From the end of the seventeenth century to the end of the eighteenth century, Notre Dame suffered significant changes and damage. During and after the French Revolution the interior was plundered and much of the art within the church was destroyed. During the nineteenth century, the Cathedral underwent a massive restoration by architect Emmanuel Viollet-le-Duc. At the end of the twentieth century, over a ten year period, the noble lady underwent another restoration. Today Notre Dame is a beautiful gothic cathedral that represents the culture and art of Paris.

Over the course of her history she has been host to various ceremonies and milestones. She was the site of Napoleon's coronation of himself as emperor in 1804, and the Mass to celebrate the liberation of Paris at the end of World War II was celebrated at Notre Dame in 1944.

Notre Dame is mentioned only briefly in *The Da Vinci Code*. According to Dan Brown, it is this cathedral that was copied when the Church of Saint-Sulpice was built. Saint-Sulpice is said to have an architectural footprint almost identical to that of the famous cathedral. (Page 88.)

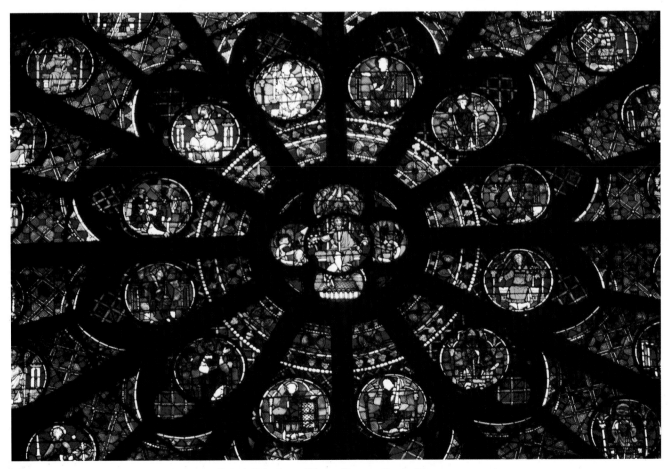

Rose Window, Notre Dame, Paris, France
Stuart Isett Photography, 2004

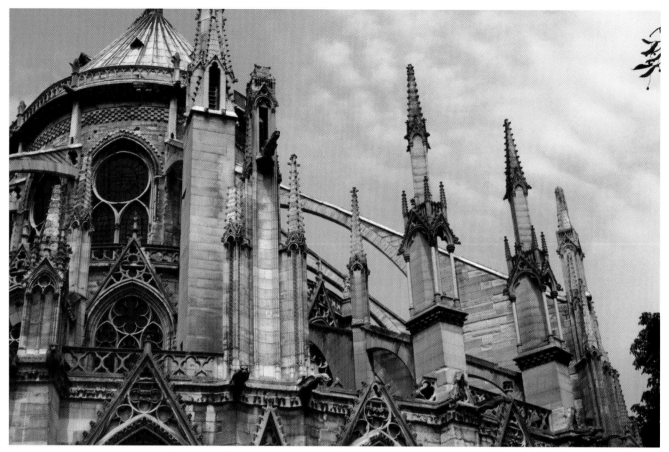

Flying Buttresses, Notre Dame, Paris, France (Stuart Isett Photography, 2004)

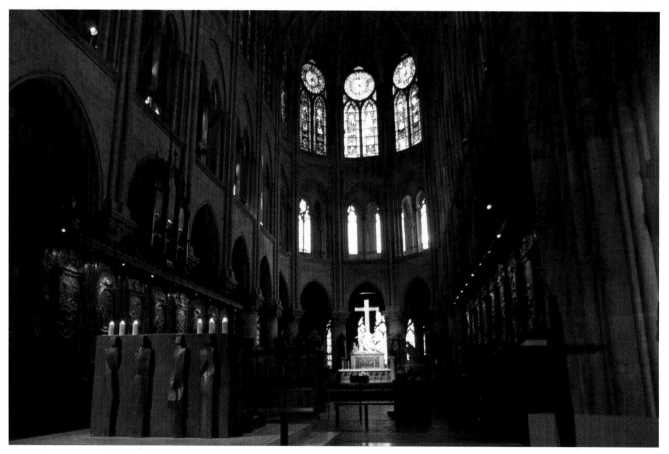

Interior Detail of Notre Dame, Paris, France (Stuart Isett Photography, 2004)

The Church of Saint-Sulpice

The building of the Church of Saint-Sulpice was started in 1646 but was not finished until approximately one hundred and thirty-five years later. It was built because the church which originally served the area of Paris where it stands was too small for its congregation. Thus, it was built near the church of Saint Germain-des-Pres in order to share its congregation. Although the exterior is not artistically pleasing, the interior houses many beautiful frescoes, many of which were painted by Delacroix.

In the transept a copper band, which is part of the Rose Line, is inlaid in the floor and runs north to south. This band connects a copper plate in the south to an obelisk in the north. At noon during the winter solstice, a ray of sunlight is said to pass through a hole in the window of the south transept and strike marked points on the obelisk. During the summer solstice a beam of sunlight is said to fall on the copper plate. Finally, during the spring and autumn equinoxes a beam of light is said to fall behind the communion table.

In 1822 Victor Hugo was married in the Church of Saint-Sulpice.

Today one of its primary attractions is its music. Its organ is the largest in Europe and the church is famous for its choir. Saint-Sulpice's music has been the subject of writers and critics for generations and is the reason that many tourists attend services here.

In the novel by Dan Brown, the Church of Saint-Sulpice is the site of one attempt to find the keystone that would unlock the secret to the location of the Holy Grail. The character Silas, a monk who is a member of Opus Dei, goes there to try to obtain the keystone. Brown takes care to describe the interior

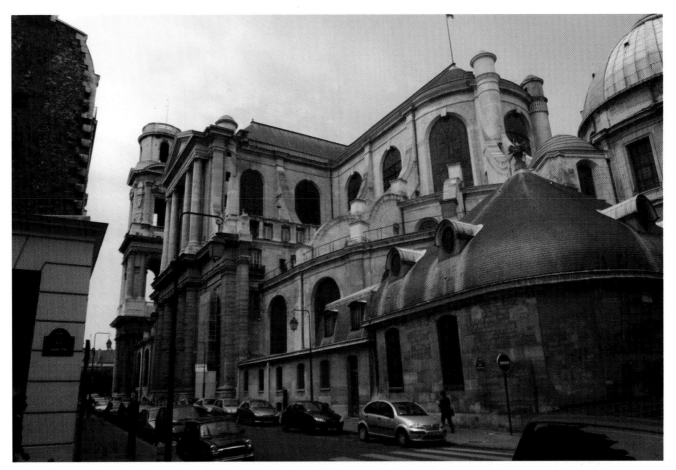

Church of Saint-Sulpice, Paris, France
Stuart Isett Photography, 2004

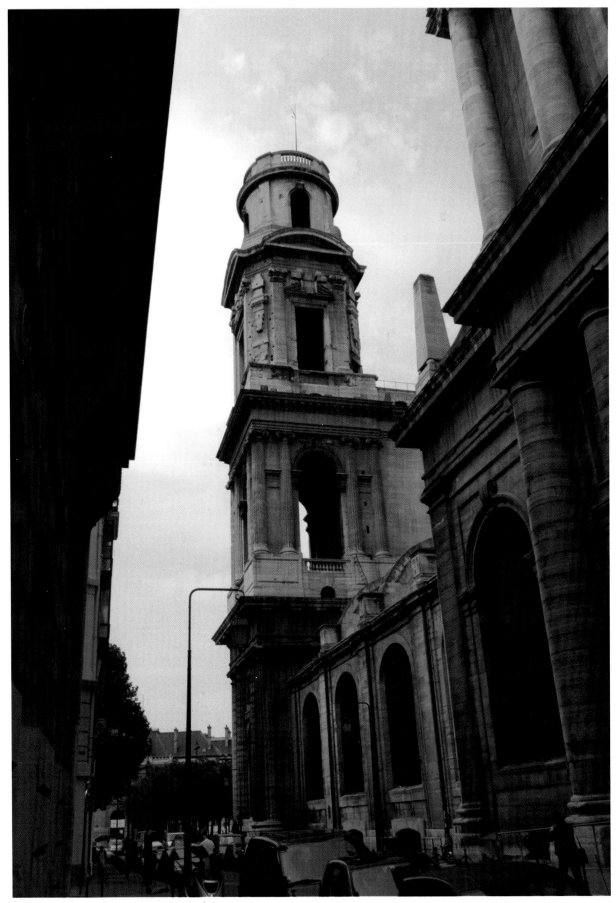

Church of Saint-Sulpice, Paris, France
Stuart Isett Photography, 2004

of the church, including the Rose Line and the obelisk, which lead Silas to the place where he believes he will find the keystone. Instead he finds a stone tablet with the inscription, "Job 38:11". Looking up the reference, he realizes that the clue that led him to Saint-Sulpice was a decoy and a dead end. Job 38:11 reads: "Hitherto shalt Thou come, but no further." According to Dan Brown's story, the decoy was to be used if one of the four leaders of the Priory of Sion was forced to tell the whereabouts of the keystone. The nun that watched over the Church was to contact the other leaders if anyone ever came there for the keystone. Silas kills the nun as she is trying to accomplish this mission. (Pages 88–90; 105–107; 115–117; 127–129; 135–136.)

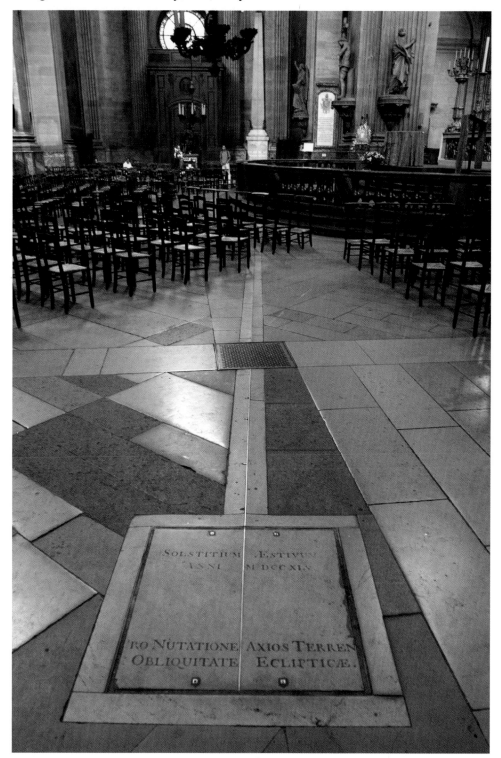

Interior detail of Rose Line, Church of Saint-Sulpice, Paris, France
Stuart Isett Photography, 2004

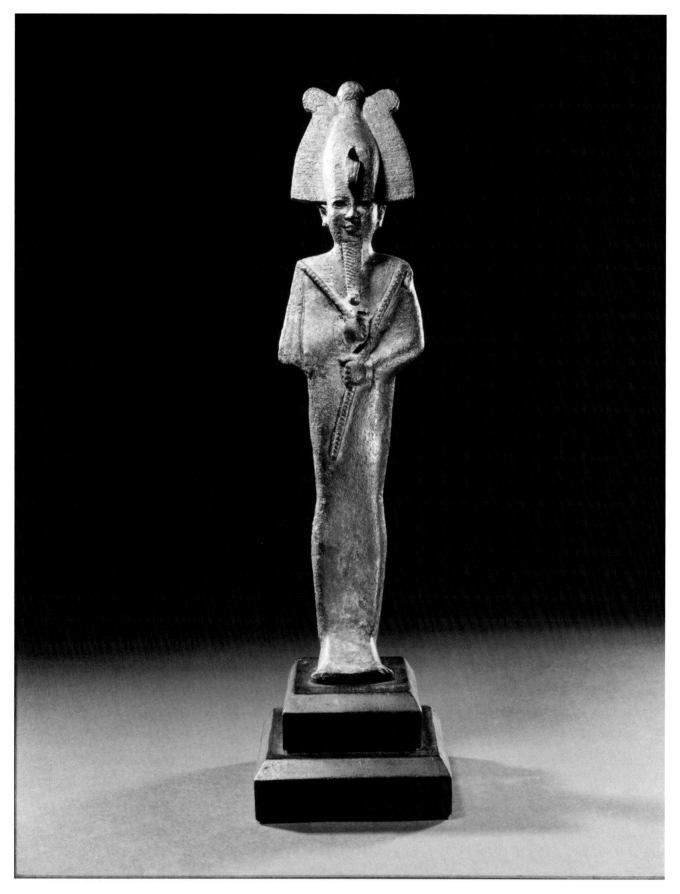

Large Bronze Figure Of Osiris
Eyptian Art
Christie's, London

Osiris

Although many Egyptian gods and goddesses were depicted as animals or as half animal and half human, Osiris was often depicted in human form, as was his wife Isis. He was considered by some as the god of goodness. Also known as the god of the underworld, Osiris presided over the tests required of the dead to be able to live eternally in the company of the gods.

The story of Osiris is one of the oldest in Egypt. It was important to ancient Egyptians for two reasons. First, he became king and ruled in a way that brought peace and a system of law to Egypt. The myth depicts Osiris as a wise leader who expanded Egypt's power and taught its people agricultural skills. Second, as the overseer of the underworld, Osiris was the gatekeeper to eternal life with gods.

According to the myth, Osiris was the son of Nut and Geb. His brother Seth, also recognized as the god of evil, plotted against Osiris and succeeded in killing him. In one version of the story Osiris' body was hacked into many pieces and scattered throughout the land. Isis, his wife, searched for the pieces of his body and buried them and built shrines in the places where she found them. Another version of the myth says Isis managed to put the pieces back together and conceive a son Horus. Depending on the version of the myth, Osiris either was resurrected or retired as ruler of the underworld.

Osiris is mentioned in *The Da Vinci Code* when Langdon refers to Isis and Osiris and their miraculously conceived son Horus. He explains that many Christian symbols came from pagan worship. Osiris' birthday allegedly was December 25. (Page 99.)

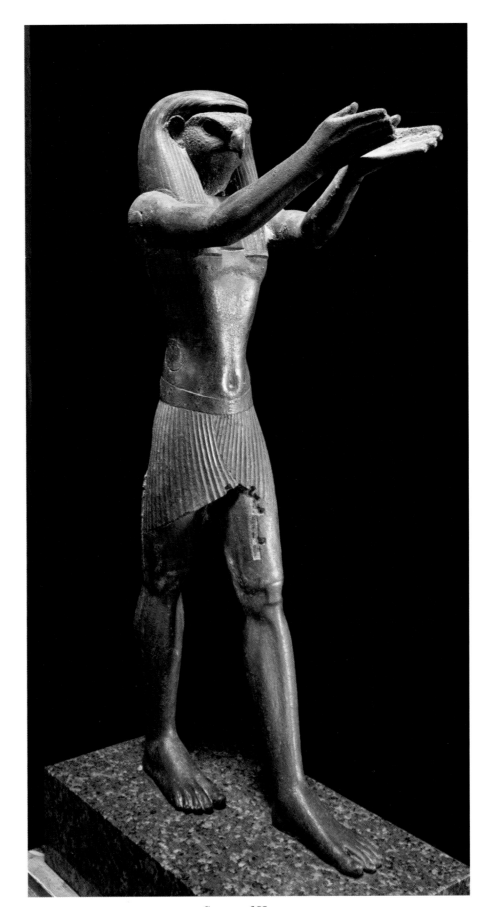

Statue of Horus
Egyptian Art
Musée du Louvre, Paris

Horus

The sky god was often depicted as a human with the head of a hawk. According to the Osiris cult, he was the son of Isis and Osiris. The myth presents him as being conceived after his father's brother, Seth, has killed Osiris. He was called by other names, one of them Harpocrates, which referred to the infant Horus, son of Osiris. As a small child he was often pictured being suckled by Isis. According to myth, he was fragile as a child and his mother had to protect him from his uncle Seth by casting spells and magic. She brought up Horus on a floating island, as another means of protecting him.

Upon reaching young adulthood, Horus began an ongoing battle with his uncle to avenge his father's death. Characterized as the proverbial struggle between Good and Evil, followers believed that eventually Horus would prevail.

Horus was viewed as a warrior and warlord. He came to be associated with the sun god, Ra, and many of the Pharaohs were looked upon as his human manifestation. Some even changed their names to include his name as part of their own, thereby strengthening their claim of godly origins.

Dan Brown refers to Horus when his protagonist, Langdon, explains how existing pagan religions influenced early Christianity. According to the text of *The Da Vinci Code,* Horus was the miraculously conceived son of Isis and Osiris. According to Brown, pictograms of Isis nursing the baby Horus were the forerunner for the images of the Virgin Mary nursing the Baby Jesus. (Page 99.)

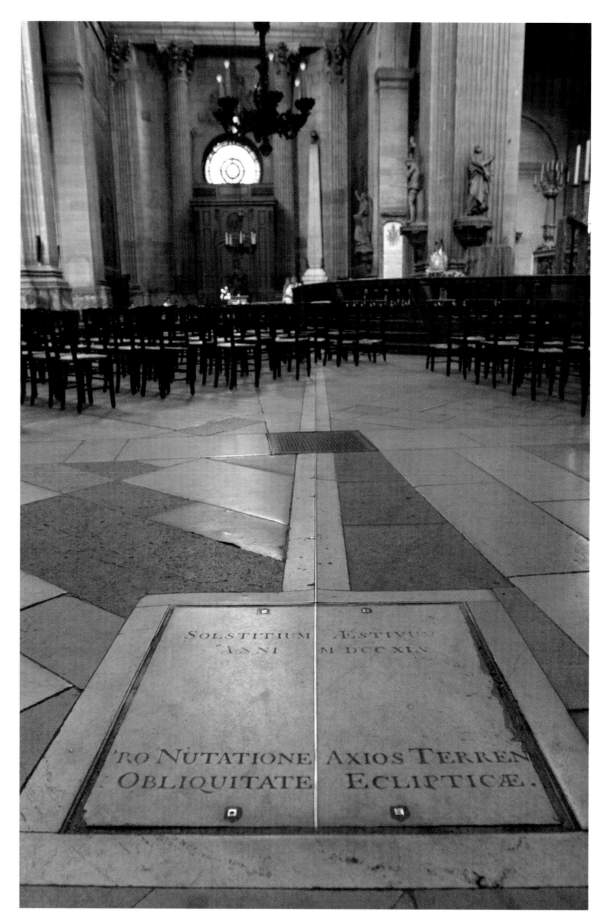

Rose Line and Obelisk, Church of Saint-Sulpice, Paris, France
Stuart Isett Photography, 2004

The Rose Line

The world's old zero longitude, the line from which all navigators worked, was located in Paris and was known as the Paris Meridien. Today it is marked by a trail of bronze disks named for Francois Arago, who traced part of its route through Paris beginning in 1806. The original monument to Arago, destroyed during World War II, stood on a pedestal that was on the Meridien. Now his monument is the trail of disks that mark the Meridien's north-south route through Paris. France didn't adopt the new zero Meridien, set in Greenwich in 1884, until 1911.

One of the landmarks that the Rose Line transverses in Paris, is the Church of Saint-Sulpice. In *The Da Vinci Code* it is described as "a strip of brass that segmented the sanctuary on a perfect north-south axis," traveling to and up an obelisk that is a significant architectural feature of the church. Legend has it that the keystone that will lead seekers to the Holy Grail lies "beneath the sign of the Rose," which could be interpreted to mean "beneath the Rose Line."

Another play on words or double entendre that can be applied to the Rose Line in this context is the idea that the Rose Line refers to the bloodline of Jesus and his mistress or wife, Mary Magdalene. Those seeking the Grail recognize the Rose as a symbol of the Grail. Further word study leads us to alternative spellings of the Rose Line, as in Roslin—the chapel and castle in Scotland with a modern spelling of Rosslyn. Although the castle no longer stands, the chapel is a site of both architectural significance and religious controversy. (Pages 105–107; 451–452.)

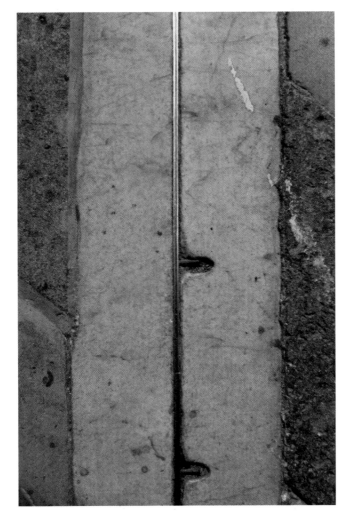

Close-up of Rose Line,
Church of Saint-Sulpice, Paris, France
Stuart Isett Photography, 2004

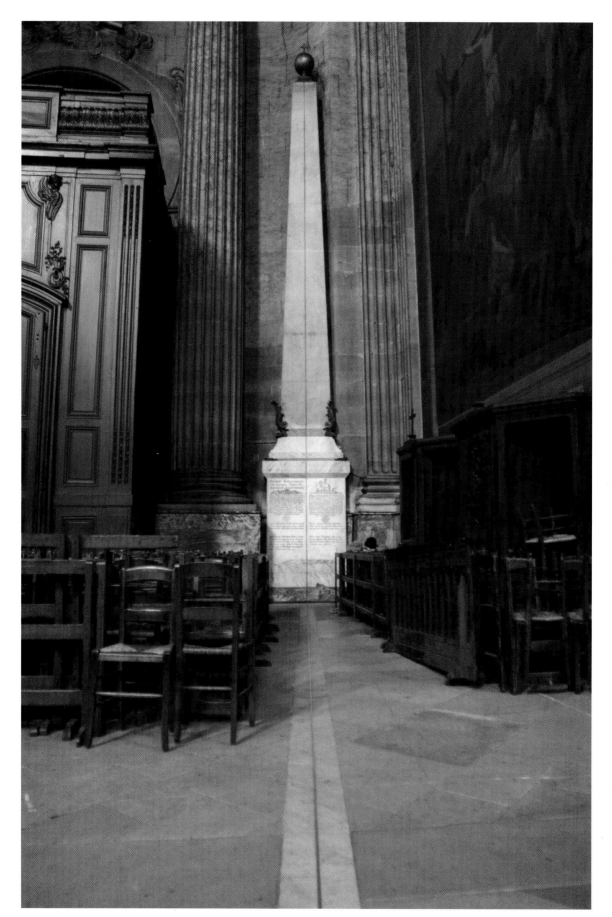

Rose Line and Obelisk, Church of Saint-Sulpice, Paris, France
Stuart Isett Photography, 2004

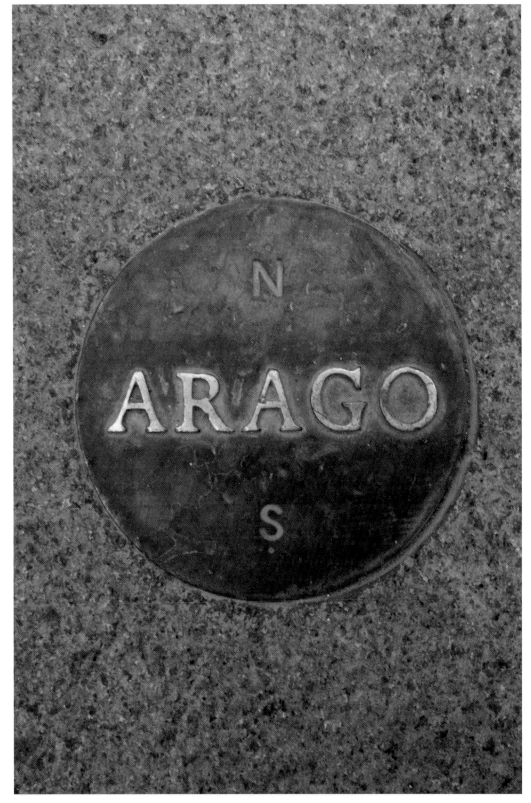

Arago Marker, Rose Line, Paris, France
Stuart Isett Photography, 2004

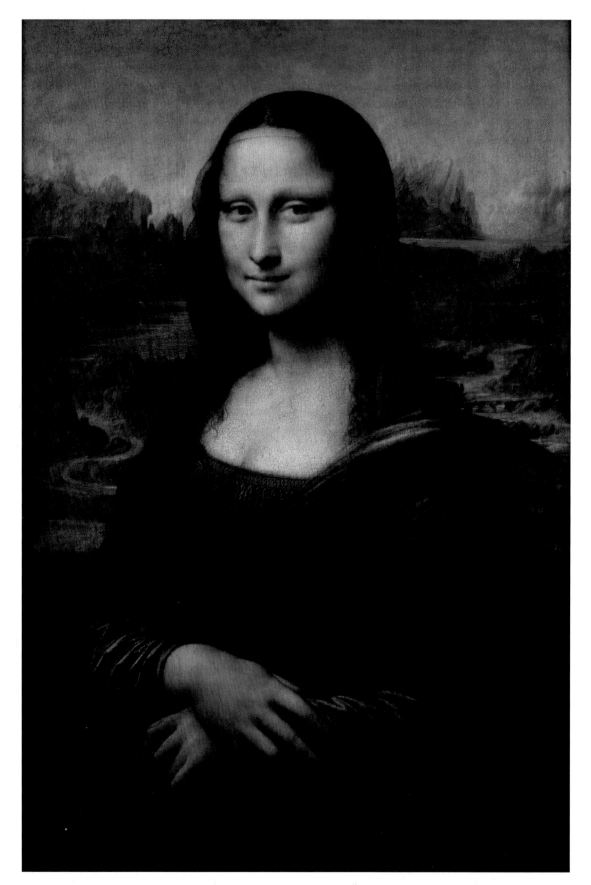

Mona Lisa
Leonardo da Vinci (1452–1519/Italian)
ca. 1503–1505
Oil on wood panel
Musée des Louvre, Paris, France

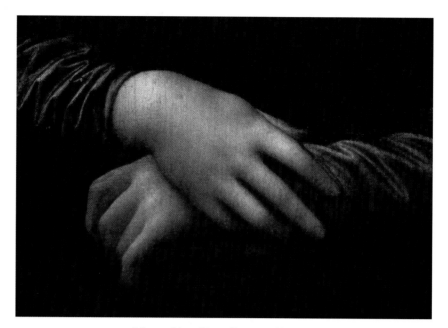

Mona Lisa (Detail) ca. 1503–06
Leonardo da Vinci (1452–1519/Italian)
Oil on wood panel
Musée du Louvre, Paris, France

Mona Lisa

The most well-known of Leonardo da Vinci's works is probably the *Mona Lisa,* which was painted between 1503 and 1505. The painting hangs in the Louvre in Paris. Over the centuries, the smile of the young woman in the painting has been described as enigmatic by both admirers and critics of the work. She appears to be serene yet distant. Unusual for the time, her gaze seems to be directed straight toward the viewer and her eyes almost issue a challenge.

Leonardo was especially gifted in the way he was able to use light and dark, highlights and shading. His gift with light and dark was especially evident in the *Mona Lisa.* He used the *sfumato* technique—light and shade that allow one form to blend in with another, leaving something to the imagination—on the corners of her mouth and eyes, which explains why she may look different at different times. He also used *sfumato* to create a dusky light in his paintings because he believed that the early evening light was best. He achieved the look by applying a thin coat of lightly tinted varnish to his works.

Brown's protagonist deciphers a clue, two lines of poetry, which are an anagram for the words "Leonardo da Vinci" and "The *Mona Lisa*". This leads Langdon and Sophie to the famous painting in search of more clues about the murderer and the message Sauniere was trying to leave his grand-daughter. Brown's characters allude to the *sfumato* technique and the enigmatic smile, and Sauniere implies that he may have understood the secret that is behind the smile.

Brown provides a vehicle for recounting other beliefs and speculations about the painting in a flashback by Robert Langdon and a discussion with Sophie. (Pages 97–102; 118–121; 124–125.)

Mona Lisa (Detail) ca. 1503–06
Leonardo da Vinci (1452–1519/Italian)
Oil on wood panel
Musée du Louvre, Paris, France

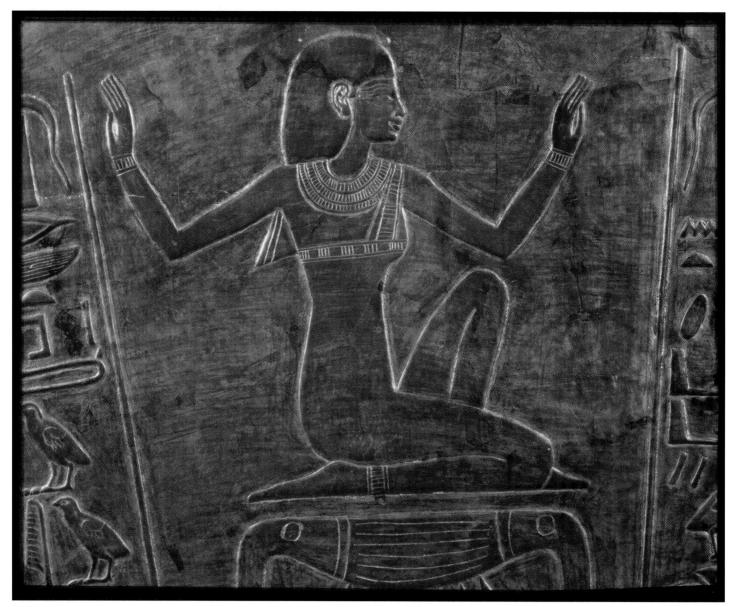

Relief of Isis from Tomb of Princess Yi
Egyptian Art
Egyptian National Museum, Cairo

the dutiful, grieving wife at his death. In some versions of the myth she is presented as a winged goddess traveling constantly, looking for her dead husband, wailing and moaning in her grief. In this form she is the wind. In other versions she is the moon goddess and her son, Horus, is the sun god.

In addition, Isis had magic powers. She used these powers to protect Horus as a boy from his uncle, Seth, who killed Osiris. These powers included knowledge of medicine and embalming and she is depicted as the protector of the dead and guardian of Osiris in the underworld. She was worshiped as goddess of wisdom and medicine.

She is often represented as a woman wearing the hieroglyphic symbol of her name on her head. Sometimes she is pictured with wings, which is unusual in ancient Egyptian mythology. Regardless of the version of her story, she is portrayed as having magical power over life and death and is the epitome of feminine mystery.

Isis is referenced in *The Da Vinci Code* in Robert Langdon's flashback to a lecture in an outreach educational program in a prison setting. She is identified as the Egyptian goddess of fertility and the feminine counterpart of Amon, the Egyptian god of fertility. In the flashback lecture, Langdon explains that the ancient pictogram for Isis was once described as "L'ISA". Thus if the two ancient Egyptian deities for fertility are written together, one has AMON L'ISA, an anagram for Mona Lisa. (Pages 120–121.)

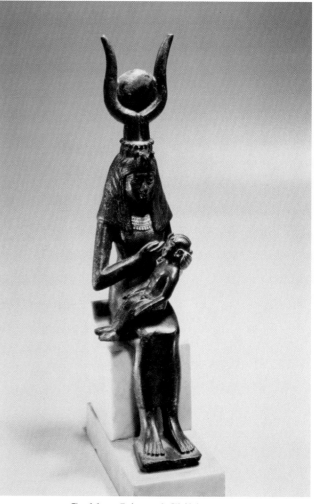

Goddess Isis and Child Horus
Egyptian Art
Musée du Louvre, Paris

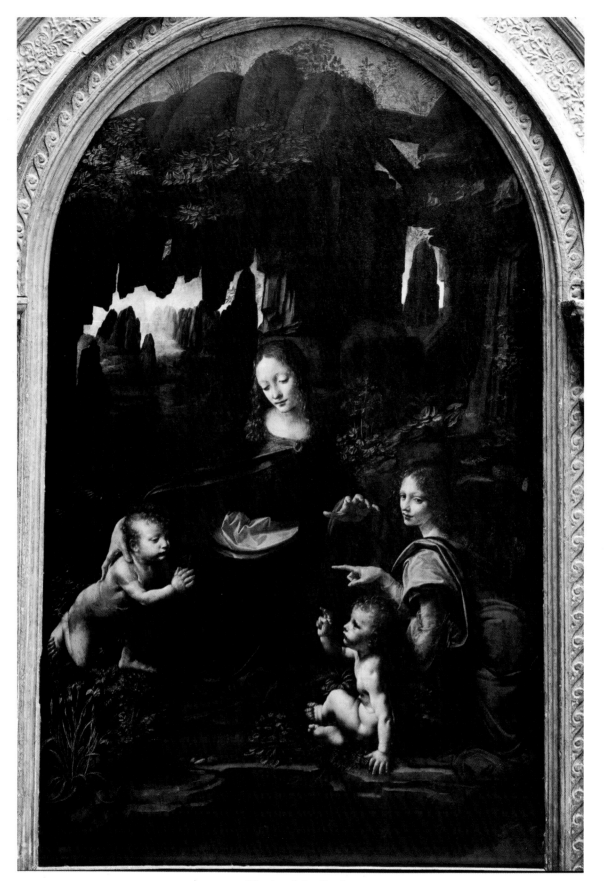

Virgin of the Rocks
ca. 1485
Leonardo da Vinci (1452–1519/Italian)
Oil on wood
Musée du Louvre, Paris

Madonna of the Rocks

The centerpiece of a larger wooden structure which included side panels, the *Madonna of the Rocks* now hangs in the Louvre in Paris. It was originally commissioned by the Confraternity of the Immaculate Conception for a new chapel in the basilica of San Francesco Grande in Milan.

The composition of the painting includes the infant John the Baptist kneeling next to the Virgin and reaching out to the Christ child. Christ is responding with a blessing. The other figure in the painting is generally considered to be an angel.

Consistent with Leonardo's use of light and dark, the figures in the painting are spotlighted against a background of darker, shadowy rocks creating almost a grotto effect. Although the varnish which he used to coat the painting has dulled some of the effects of the coloration, generally it is well preserved. Although begun in 1483, the work was not completed until 1508.

This painting hangs directly across from the *Mona Lisa* in the Louvre. Brown uses it to further the series of riddles that become the skeleton for his plot. According to Sophie, her grandfather never brought her to see the *Mona Lisa* without visiting the *Madonna of the Rocks*. In *The Da Vinci Code*, Sophie finds an anagram written by a black light pen across the glass covering the *Mona Lisa* that points her to the *Madonna of the Rocks*. Sophie visits this painting after being led to the *Mona Lisa* and finds the Priory of Sion key that her grandfather had promised her as a child. Sophie uses the painting as a shield to escape the Louvre to go in search of the box the key opens and the answers to the riddles her grandfather has left.

According to Langdon, the painting contained details that horrified its commissioners. Leonardo then painted a more orthodox version that hangs in the National Gallery in London under the name *Virgin of the Rocks*. (Pages 124; 131–134; 138–139.)

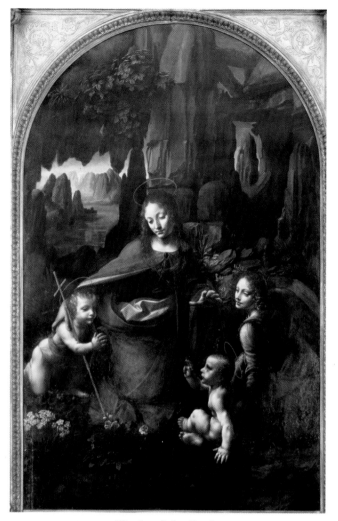

Virgin of the Rocks
ca. 1485
Leonardo da Vinci (1452–1519/Italian)
National Gallery, London, England

✦ 42 ✦

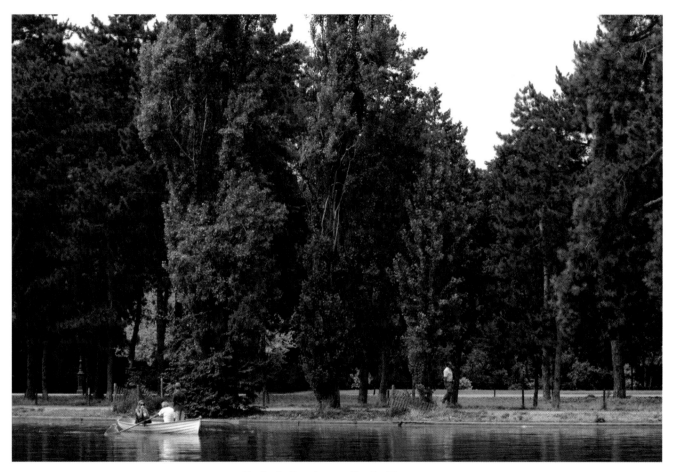

Bois de Boulogne, Paris, France
Stuart Isett Photography, 2004

Bois de Boulogne

Located on the western edge of Paris, the land known as the Bois de Boulogne was given to the city of Paris by Napoleon in 1852. Baron Haussman designed the park to resemble the large sprawling parks of London. It is recognized today as one of the most outstanding parks in Europe.

It contains two lakes, a waterfall, walking paths, gardens and parks within the park. Horse drawn carriages travel through the park, as do automobiles. There are two racetracks. One is Longchamp, where the Grand Prix is run each year. One of the gardens is for children and contains a zoo, an amusement park and a narrow-gauge railway.

The Parc de Bagatelle (a park within the park) is the site of a palace built in only three months by the Comte d'Artois. The gardens of the Bagatelle are renowned for their tulips and roses.

The park is a retreat for locals and tourists during the day, with its paths and restaurants and various recreational offerings. However, at night it takes on a very different character. The Bois becomes the red light district of Paris at night and shelters a very different population. Prostitutes and muggers abound and a stroll through the park after dark can be a dangerous undertaking.

In *The Da Vinci Code,* the Bois de Boulogne is part of the escape route for Sophie and Langdon as they run from the authorities in Paris. (Pages 157; 161; 164–165; 168.)

Bois de Boulogne, Paris, France
Stuart Isett Photography, 2004

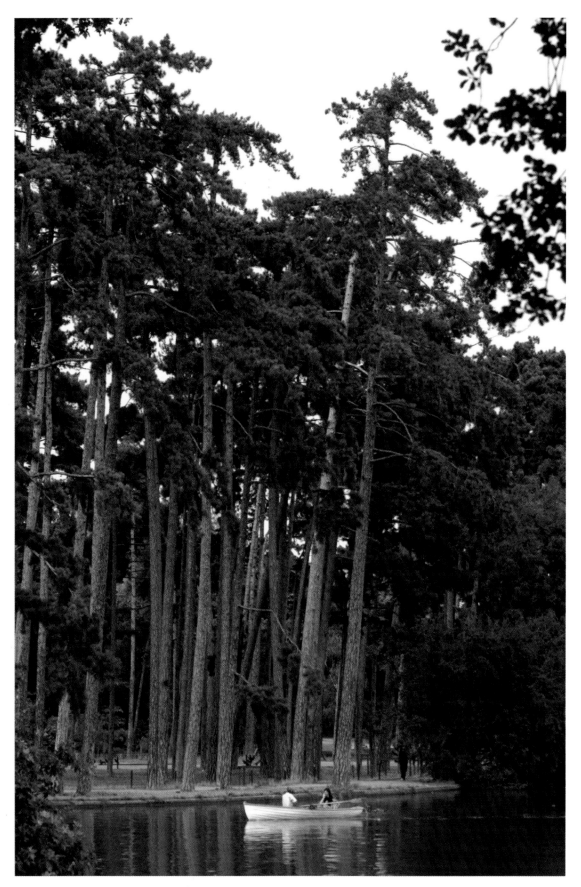

Bois de Boulogne, Paris, France
Stuart Isett Photography, 2004

Knights Templar and the Priory of Sion

Some controversy exists regarding the origin of the Knights Templar, but most accounts indicate that they were created by a secret society known as the Priory of Sion during the Crusades to the Holy Land. The Priory was a very influential secret organization in Europe and a list of the Grand Masters of the Priory allegedly would include such people as Leonardo da Vinci and Sir Isaac Newton. Some accounts cite Christopher Columbus as a member of the Priory of Sion.

The Knights Templar were Crusaders who took vows of poverty, chastity and obedience and were committed to protecting and defending Christians traveling to and from Jerusalem. Originally they were known as the Poor Fellow Soldiers of Jesus Christ. In 1118 CE they were officially recognized by the Roman Catholic Church and they set up their headquarters on the site of the former Temple of King Solomon. Thus they were known as the Knights of the Temple or Knights Templar. The influence of the Templars grew as they became known as fierce fighters, and they set up depositories where the wealthy could leave goods or treasure during a crusade. They eventually functioned as the first international bankers.

On a Friday the 13th in 1307, the Templars in France were charged with heresy and declared outlaws by Pope Clement. He was influenced by the King of France, Phillip IV, who did not want to have to repay loans to the Templar Bank and who wanted their wealth as his own. Many were rounded up and later tortured and killed. One group escaped to Scotland and managed to take the treasure in the French Templar banks with them. History tells us that the leader of the Templars in France, Jacques de Molay, cursed both the King of France and the Pope just before his death. Ironically both were dead within a year. Many attribute this to the influence of the Priory, although there is no hard evidence to support the theory.

Once the Templars were outlawed, they went underground. The Templars worked against the Roman Catholic Church and supported the Protestant Reformation. They were persecuted by the Catholic Church and, in particular, by the Jesuits, who were the Vatican's soldiers. Some have written that they operated in Europe and England as the Freemasons and that there is an unbroken line of Grand Masters to this day.

The current Knights Templar simply state that the organization emerged in the early 1700s as part of the Freemasons. They do not claim a connection between the ancient order and the modern day organization.

Allegedly the Boston Tea Party was organized by the Freemasons and the United States' Declaration of Independence was written and signed primarily by Freemasons. George Washington and many of his generals supposedly were Freemasons.

According to literature of the current organization, the Knights Templar are the top rank of Masonic orders, known as the "York Rite of Freemasonry." All Knights Templar are members of the Freemasons, but not all Masons are Knights Templar. To become a Knight Templar, one must first be a member of the Freemasons.

The modern day Knights Templar are first and foremost a Christian fraternal organization. Their stated mission is to help others and, just as the Masons work to support various charities and community activities, so do the Templars. One such charity is the Knights Templar Eye Foundation, Inc. They support an educational foundation that provides low interest loans to students. They also support an annual Holy Land Pilgrimage that sends a Christian minister to the Holy Land.

Dan Brown alludes to the Priory early in his book but doesn't fully explain its place in history until Langdon begins telling Sophie about the Priory and her grandfather's role as Grand Master. This is the reason her grandfather was murdered, and sets the stage for the mystery that follows. (Pages 157–161; 253–262.) A list of other alleged Grand Masters is provided on pages 326 and 327.

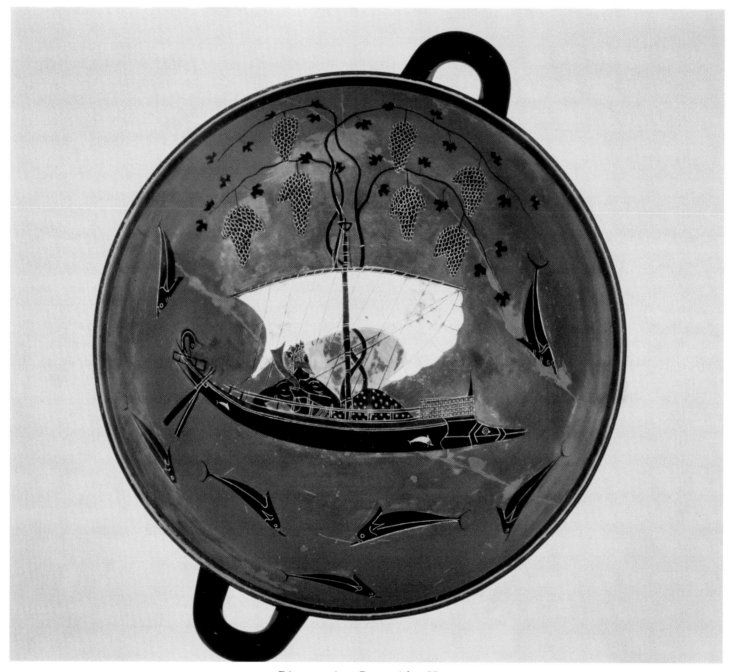

Dionysus in a Boat with a Vine
ca. 540 BC
Exekias (6th Century BC/Greek)
Ceramic
Staatliche Antikensammlung, Munich, Germany

Dionysus

Dionysus, also known in Rome as Bacchus, is the god of wine, agriculture and fertility. He is also the god of the drama, especially tragedy, in Greece. In art he is depicted wearing a wreath of vine leaves. Wine was an important component in the rituals that honor him. It also contributed to the achievement of ecstasy, delivery from the physical world through intoxication.

Two myths are associated with his birth. According to one, Dionysus is the son of the god Zeus and the mortal woman Semele. Semele died before she gave birth to Dionysus and Zeus rescued the embryo, implanting it in his thigh. After the infant was born Zeus gave him to nymphs to raise. The other myth portrays Dionysus as the son of Zeus and Persephone, the queen of the underworld. Hera, Zeus' wife, sends Titans to kill the child and he is ripped to pieces. Zeus saves the heart and implants it in the womb of Semele. These stories of his birth give rise to the myth that Dionysus was "twice born."

Dionysus was the god who granted King Midas the ability to turn everything he touched into gold. When Midas was faced with starvation because of the "gift," he begged to have the power removed. Dionysus sent Midas to the river Pactolus and the waters washed the power away. According to legend, the sands of the river were changed into gold.

The reference in *The Da Vinci's Code* to Dionysus occurs in a discussion of pagan symbols that have been adopted or borrowed by the Christian church. According to Brown's character Leigh Teabing, December 25 is also the birthday of Dionysus. (Page 232.)

Dionysus II
Harold Stevenson (1929–1984/American)
Mixed Media
Chisholm Gallery, West Palm Beach, Florida

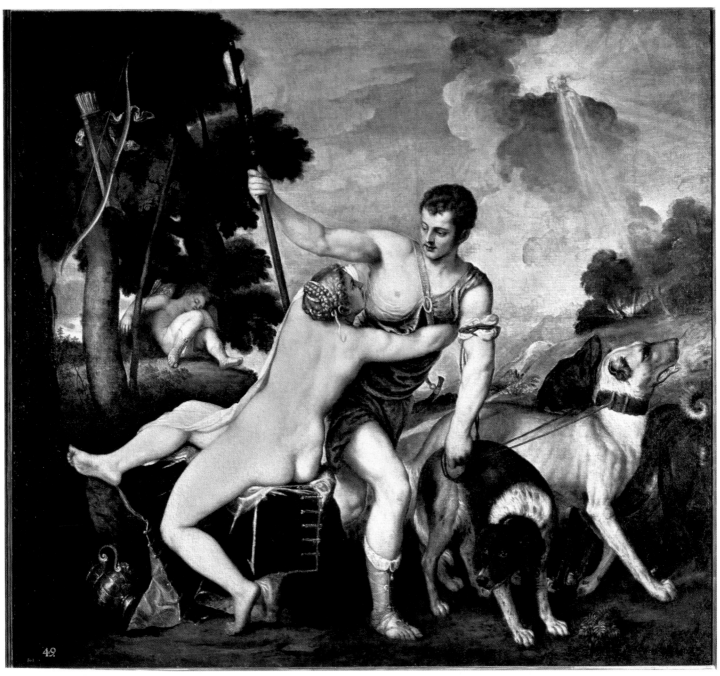

Venus and Adonis
Titian (ca. 1485-1576/Italian)
ca. 1553
Oil on canvas
Museo del Prado, Madrid, Spain

Adonis

Although there is some disagreement about his parentage, the most generally accepted version of the myth portrays Adonis as the son of King Cinyras and his daughter, Myrrha. When Cinyras realized what he had done due to his daughter's deception in disguising herself, he tried to kill Myrrha. Aphrodite turned the daughter into a myrrh tree (from her name Myrrha). The tree later split and Adonis was born. After the child was born Aphrodite protected him and sent him to Persephone, who hid him in the underworld.

Again there is some dispute over the details of the myth, but the overall story is that both Aphrodite and Persephone were taken with Adonis because of his beauty and wanted him. According to one version of the myth, Zeus mediated the dispute; according to others he sent the muse Calliope to mediate. Regardless, the outcome was that Adonis would spend one third of the year with Aphrodite and one third of the year with Persephone. Adonis could choose where he would spend the last third of the year. Some say he chose to spend that third of the year with Aphrodite. Thus we have the seasons. The months that he spends with Aphrodite we experience as spring and summer. The months that he spends with Persephone we have winter.

Adonis allegedly continued to divide his time in this fashion until he was killed by a wild boar. Aphrodite was so distraught by his death that she changed his blood into a flower with the color of the pomegranate. According to the legend the wind blows the blossoms open and almost immediately blows the petals away, so it is called the Wind Flower or Anemone.

As with Dionysus and Osiris, Adonis is mentioned in *The Da Vinci Code* in a discussion of the fusing of symbols and rituals of one religion into another. Like Dionysus and Osiris, Adonis' birthday allegedly is December 25. (Page 232.)

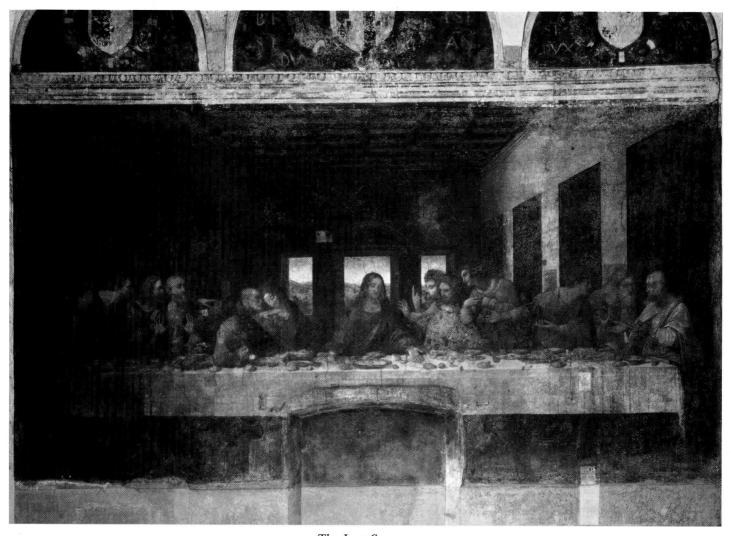

The Last Supper
Leonardo da Vinci (1452–1519/Italian)
ca. 1495–1498
Fresco
Convent of Santa Maria delle Grazie (Refectory), Milan, Italy

The Last Supper

Leonardo painted *The Last Supper* on the wall of the refectory in the Monastery of Santa Maria delle Grazie, Milan, Italy. It was painted on plaster with an oil and tempera paint that began to deteriorate almost immediately. Many attempts have been made over the years to halt its deterioration and restore it to its original state.

The subject of the painting is the last supper of Christ with his disciples. Allegedly Leonardo painted the individuals based on people he actually knew. He arranged the figures in four groups of three, which may or may not have been a deliberate reference to numerical symbolism. Controversy exists as to whom exactly some of the figures represent. Most scholars agree that the painting is supposed to depict the moment when Christ told the disciples that one of them would betray him. This accounts for the expressions and agitation on the faces of the figures in the painting. Christ is serene in the midst of the emotion his announcement has created.

Brown uses a discussion of *The Last Supper* to educate readers about the Holy Grail. Often described as

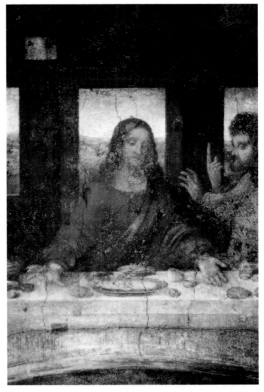

The Last Supper, Detail
Leonardo da Vinci (1452–1519/Italian)
Santa Maria delle Grazzie, Milan, Italy

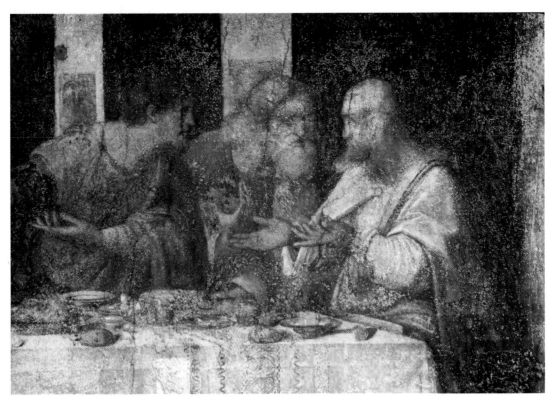

The Last Supper, Detail
Leonardo da Vinci (1452–1519/Italian)
Santa Maria delle Grazzie, Milan, Italy

a chalice, the grail takes an entirely different form in this setting. According to Brown, the Holy Grail is not a cup or chalice, but a person. Also according to Brown, Leonardo da Vinci has revealed the identity of the Grail in *The Last Supper*. Thought by many to be a painting of Jesus and his disciples, all men, according to Brown, *The Last Supper* may be a painting of Jesus and his disciples, but they are not all men. Brown goes into great detail to make the reader aware of the ancient symbols representing male and female. Then he re-veals the fact that the disciple seated to Jesus' right is a woman and asserts that she is Mary Magdalene. Next he has us focus on the forms of Jesus and Mary Magdalene as compositional elements instead of people. When one does so, one sees that the position of their bodies creates a very large letter "M". This "M" allegedly refers either to *matrimonio* or *Mary Magdalene*. Brown asserts that the letter "M" is found hidden in other works either produced or commissioned by members of the Priory of Sion. (Pages 235–250.)

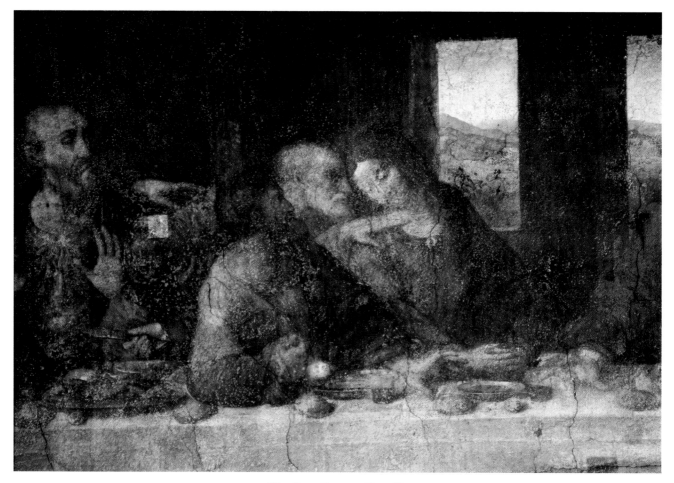

The Last Supper, Detail
Leonardo da Vinci (1452–1519/Italian)
Santa Maria delle Grazzie, Milan, Italy

The Holy Grail

The Holy Grail endures as a symbol, although the details of its story vary from writer to writer and from culture to culture. There are certain points that most accounts of the story share. The most widely accepted version of the myth presents it as the cup or chalice used by Jesus at the Last Supper. Legend has it that Joseph of Arimathea obtained the cup and used it to catch Christ's blood as he died on the Cross. He took the cup to Great Britain and allegedly retained possession of it until he died, at which time either his family obtained the cup or it was hidden.

At this point the Arthurian legends, probably of Celtic origin, are interwoven with the quest for the Grail. Most of the Grail romances appeared between the years 1180 and 1240. In literature the Grail first appears in the unfinished poem *Conte del Graal,* written by Chestien de Troyes. Approximately ten years later, Robert de Borron produced a work, *Roman de l'histoire dou Graal,* of which only two parts remain, the "Joseph d'Arimathie" and "Merlin." The most detailed story of the Grail is supposed to be the *Grand St. Graal* written in France in the mid thirteenth century. There were other French romances dealing with the Holy Grail, but the most well known to English readers is the *Queste del St. Graal,* which was included almost entirely in Malory's *Morte d'Arthur.* Some authors emphasized the Christian elements of the story while others emphasized the mystical. The Grail legend disappeared in literature at the beginning of the fourteenth century. It did not appear again until the nineteenth century.

Although the predominant grail story is a Christian-based legend, the organized Church did not support or even acknowledge the legend. This can be attributed to the fact that its religious origins are not canonical or recognized by the Church. Further, if Rome had recognized the legend as having value, Britain would have attained a status that Rome was not willing to share.

Dan Brown introduces the reader to another theory of the Grail—one which he claims is well known in certain secret organizations. He has Langdon expound on this theory in his explanations to Sophie. According to Brown, the idea that the Grail is a chalice is a metaphor for a woman. The Holy Grail represents the sacred feminine, the lost goddess. Knights who were searching for the Grail were, in fact, searching for the sacred feminine.

Not only is the Grail a woman, it is a specific woman—Mary Magdalene. Brown claims that the figure to the right of Jesus in Leonardo's *The Last Supper* is none other than Mary Magdalene. He explains that the image of Magdalene as a prostitute was the product of a smear campaign by the early Church to discredit her and to hide her role as the Holy Grail. Brown presents the argument that Mary Magdalene was married to Christ and says that Leonardo was aware of this fact when he painted *The Last Supper.* He explains that as a Jew, Jesus would have conformed to the social requirements of the time which forbade a Jewish man from being unmarried. He references the Dead Sea Scrolls, which present Magdalene as "the companion of the Savior," a synonym for "spouse" in the language of the time.

He goes on to cite the Gospel of Mary Magdalene and claims that Jesus intended for Magdalene, not Peter, to be the rock upon which his church was built. He explains that she was from the tribe of Benjamin, of royal descent. Jesus was of the House of David, a descendent of King Solomon. Uniting the two bloodlines created a powerful union with the potential to reinstate the line of kings for Israel.

Brown develops this further by explaining that Mary Magdalene was the "Holy Vessel"—the chalice that carried the royal bloodline. She was pregnant at the time of the crucifixion and had to flee the Holy Land. Joseph of Arimathea helped her escape and travel to France where her daughter Sarah was born. The Jews in France protected Magdalene and her child. The Sangreal documents preserved the documented genealogy of Christ's bloodline.

According to Brown's characters, the Knights Templar were charged with protecting the documents and the bloodline. The hiding place of the Grail includes both the Sangreal documents and the bones of Mary Magdalene. Thus the search for the Grail was actually a search for the Magdalene. A descendant of Mary Magdalene allegedly was the founder of the Priory of Sion. (Pages 237–239; 242–250; 253–259.)

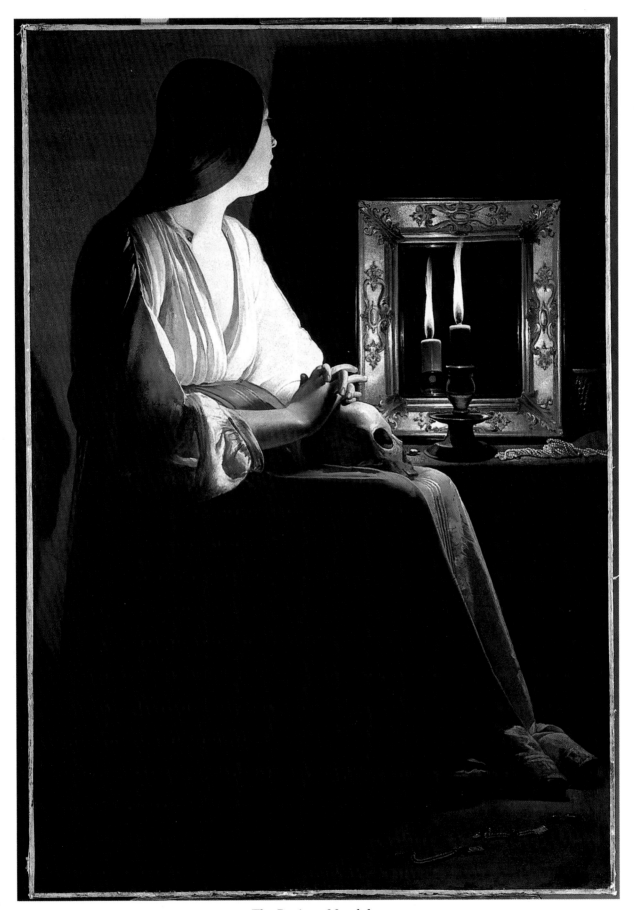

The Penitent Magdalen
Paintings. French.
The Metropolitan Museum of Art, Gift of Mr. and Mrs. Charles Wrightsman, 1978. (1978.517)
Photograph © 1997 The Metropolitan Museum of Art

The Penitent Magdalen

Painted by Georges de la Tour between 1638 and 1643, *The Penitent Magdalen* hangs in the Metropolitan Museum of Art in New York. La Tour's paintings are characteristically lit by candlelight or torch light and have a meditative or spiritual quality about them. *The Penitent Magdalen* is no exception. It shows the full-length Magdalene seated, holding a skull in her lap and pensively looking into a mirror lighted by a candle that is reflected in its surface. The effect is both mysterious and calming. It is also an example of la Tour's being influenced by the chiaroscuro of Caravaggio. The term chiaroscuro (from the Italian words *chiaro,* meaning "light," and *scuro,* meaning "dark") refers to the use of light and shade in a work of art to define three-dimensional objects. The principle behind chiaroscuro is to leave the light parts as they are so that they can be seen clearly and to darken the "obscure" parts (defined as the parts the artist deems less important) so that they will not distract the viewer.

Georges de la Tour, the son of a baker, was born on March 14, 1593, in Vic-sur-Seille near Nancy, France. He moved to Luneville, fifteen miles south of Vic-sur-Seille, in 1620, where he lived for the rest of his life. He was a successful master painter during his lifetime but was almost forgotten after his death. His work was rediscovered in 1915 by the German art historian Hermann Voss, Director of the Kaiser Friedrich Museum in Berlin.

In *The Da Vinci Code, The Penitent Magdalen* is mentioned on one of the occasions when Langdon is explaining the link between Disney and the Priory of Sion. According to Langdon, Walt Disney was regarded as a modern day Leonardo da Vinci. He allegedly filled his work with hidden meaning and symbolism, as did Leonardo. Langdon points out that much of Disney's early work deals with the "incarceration of the sacred feminine," that is, Cinderella, Sleeping Beauty and Snow White. A more recent Disney production that champions the sacred feminine is *The Little Mermaid,* and Langdon claims that the painting in that heroine's home is *The Penitent Magdalen.* According to Langdon, *The Little Mermaid* continuously references the sacred feminine. (Page 262.)

Shekinah

Shekinah is a feminine noun in Hebrew. Although the word *Shekinah* is not found in the Bible, verbal cognates do appear in the Bible and are used to describe or refer to the presence of God. In ancient writings from Jewish mysticism, the Shekinah was recognized as one of the ways God presented himself to humanity. The Shekinah is also recognized as the Bride of God and the feminine manifestation of God.

Because the ancient Hebrews believed that man should not or could not actually see God, one way to explain Moses' meetings and conversations with God was to have God appear in another form. The cognate that Shekinah derives from is *shakan,* which means "abiding or dwelling." Thus the word Shekinah came to be used to name the mystical presence of God on earth. It explained God's appearances, for example the pillar, cloudy by day and fiery by night, that led Israel out of Egypt and into the wilderness. The concept of Shekinah also explained the fire and cloud that covered Mount Sinai when the commandments were handed down. It was a physical manifestation of the presence of God among the Hebrews and inhabited the tabernacle and the land of Israel.

The concept of the Shekinah was not officially carried over into Christianity. However, we do see remnants of Her in the Roman Catholic tradition in the Holy Mother, the Virgin Mary. Also, the Christian concept of the Sophia, the wisdom or feminine side of God, is not totally unlike the concept of the Shekinah.

Brown refers to the Shekinah when Robert Langdon is attempting to explain the ritual of Hieros Gamos to Sophie. According to Langdon, to the ancients, sexual intercourse was the union of the two parts of the spirit, male and female. It was the means for the male to reach spiritual union with God. The early Jews believed that not only God, but also his female equal, Shekinah, inhabited Solomon's Temple. The Jewish symbol for God, YHWH, comes from the word Jehovah, a combination of the masculine Jah and the name for Eve, Havah. According to Langdon, ancient Jewish men would come to the Temple seeking spiritual wholeness, which they believed they accomplished by having intercourse with the Temple priestesses. (Page 309.)

Baphomet

Baphomet was an idol described as having the head of a goat, wings, pendulous breasts and cloven feet. One of the accusations brought against the Knights Templar, for which they were tortured and burned at the stake, was that they worshipped the idol Baphomet. Also included in the heresy charges against the Templars was that some worshipped Mohamet, or Mohammed in English. The name Baphomet was derived from the word Mohamet. Twentieth-century historians have generally dispelled these accusations against the Knights Templar.

One reason the idol remains somewhat of a puzzle is that most descriptions of him came from confessions from the Templars during the Inquisition. They were confusing and not consistent. One theory is that these "confessions" were the result of torture, not truth.

Regardless of the nature of the Knights Templars' association with the concept of Baphomet, the myth did survive in world of the occult. There, Baphomet is recognized as the god of witches or the deity of the sorcerers—Sabbaat.

When trying to decipher a riddle that is believed to be a clue to finding the keystone, Langdon ponders the line "A headstone praised by Templars . . ." He interprets the phrase to mean not a grave marker, but literally a stone head praised by Templars. This provides the opportunity to discuss the some of the rituals attributed to the Templars, specifically the worship of the pagan god Baphomet. Langdon explains that Baphomet was a pagan fertility god represented as having the head of a ram or goat. This was a symbol of fertility for the ancients. Langdon even links the modern image of a horned devil to the images of Baphomet. He accuses the Christian church of linking the ancient fertility symbol with evil. Finally, according to Langdon, the horn of plenty, or cornucopia, was a reference to the horned fertility god Baphomet. (Pages 316–317.)

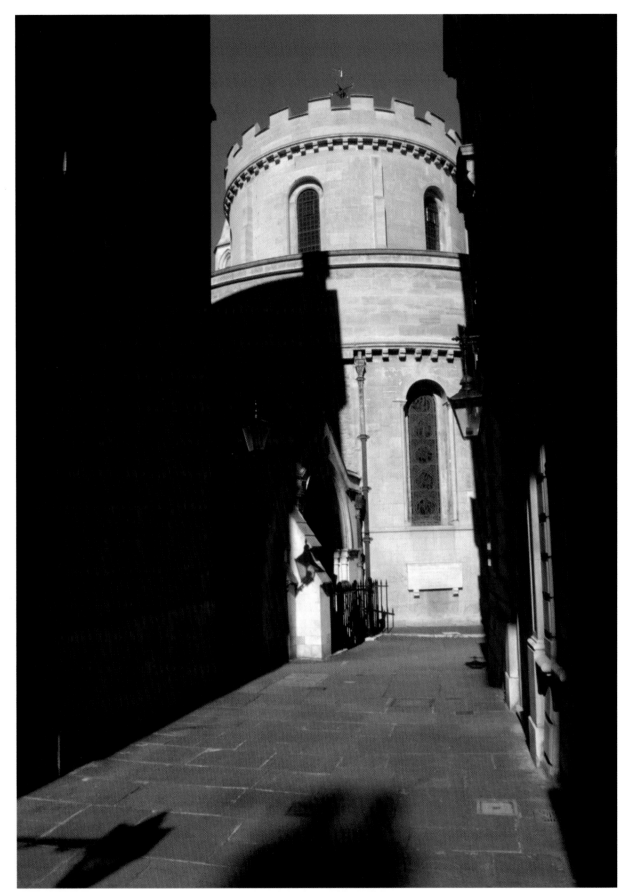

Temple Church, London, England
Stuart Isett Photography, 2004

The Temple Church

Named for and built by the Knights Templar, The Temple Church was consecrated in honor of the Virgin Mary on February 10, 1185. The London Church was the headquarters of the Knights Templar in Great Britain. The Templars were an order of soldier monks whose published mission was to protect pilgrims traveling to and from Jerusalem in the twelfth century. The Church is composed of two parts, the round and the chancel, the space around the altar of a church. The original round church was designed to model the circular church of the Holy Sepulchre in Jerusalem. Its shape was designed to protect the most sacred of places, the center, and the place of Jesus' own burial. Every church that the Templars built in Europe contained this most holy place. The Temple Church, as a replica of the church in Jerusalem, was a replica of the Sepulchre itself.

The original plan was modified between 1220 and 1240 when a rectangular chancel was added by Henry III. Although he intended to be buried there, he was in fact buried in Westminster Abbey. One architectural phenomenon of the chancel is the outward-leaning columns. Although the columns that exist now are not original, their leaning is deliberate. The church was bombed in 1941 and the original columns were broken. Since they had leaned for some 700 years, it was decided that their replacements should lean too. The Temple Church is one of the oldest buildings in London.

Within the London church are life-size stone effigies of nine knights laid upon the floor. The most famous of these is that of Sir William Marshall, Earl of Pembroke, who died in 1219 and was an advisor to King John and Henry III. His sons' effigies lie around him. They are all portrayed in their early thirties, poised to spring to battle when called by Christ.

The Knights wore white robes with red crosses. Thus, according to the book of Revelation, they would be ready, clad in white robes washed in the blood of Lamb, when called to life at the resurrection. The Templars believed that the final battle against Satan would be in Jerusalem. By being buried in the Temple, the replica of the Sepulchre in Jerusalem, they were in essence buried in Jerusalem and they would be ready for the call to arms for the sacred battle.

The Temple church is one of the locations that Brown sends his characters to look for the Grail. Having his protagonist and fellow searchers go there allows the author to describe the architecture of the church, its history and the unusual effigies that lie there. (Pages 343–347; 353–362.)

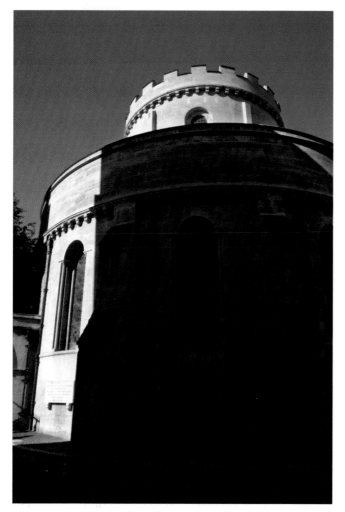

Temple Church, London, England
Stuart Isett Photography, 2004

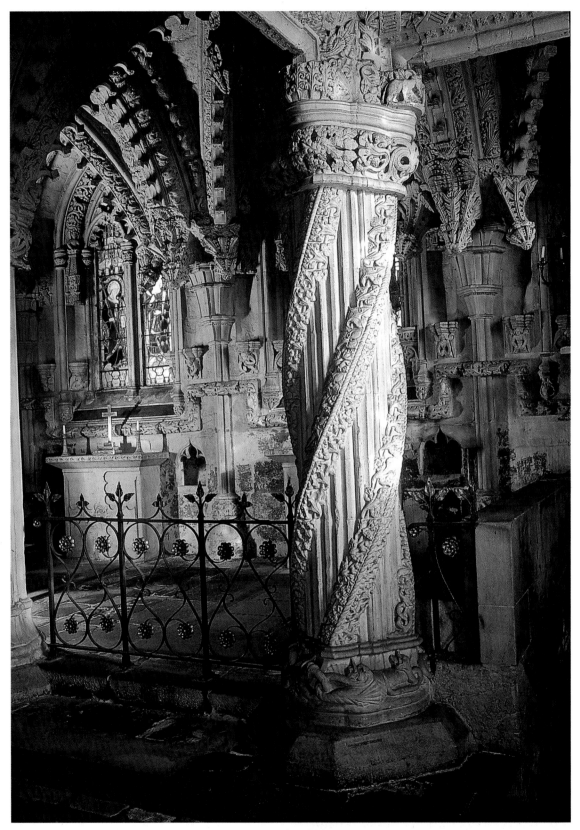

Apprentice Pillar
Rosslyn Chapel, Scotland
© Antonia Reeve/Rosslyn Chapel Trust

Rosslyn Chapel

The Rosslyn Chapel was begun on St. Matthew's day, September 21, 1446. Foundations for a much larger building were found and excavated in the nineteenth century and it appears that the chapel now standing is what would have been the choir of a much larger structure. Based on these excavations, it is believed that the final building was to have been in the form of a cross with a tower at its center. It was begun as a collegiate church by Sir William St. Clair, who died in 1484 and was buried in the unfinished chapel. His son Sir Oliver St. Clair roofed the chapel/choir but did not continue or complete his father's plan.

With the Reformation came the decree to destroy the altar of the chapel in 1592. After that, the chapel ceased to be a place of worship for almost four hundred years. Cromwell's troops used the chapel as a stable and in 1688 it is said that villagers entered the chapel to destroy any remnants of Catholicism that might still be present there. Finally in 1736 Sir James

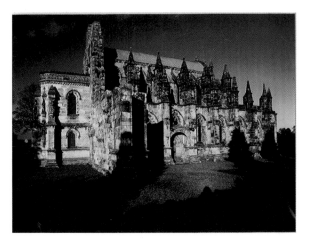

Rosslyn Chapel, Scotland
© Antonia Reeve/Rosslyn Chapel Trust

St. Clair began to restore the chapel. Additional repairs were made in the nineteenth century and in 1861 James Alexander, 3rd Earl of Rosslyn, set out to have services held at Rosslyn again. The chapel was rededicated on April 22, 1862.

Architecturally, Rosslyn Chapel is considered to be very unique. The only wood in the building is the two Chapel doors and oak tracery in an apse that was added in the late nineteenth century. There is a central pendant at the east end of the chapel with a representation of the Star of Bethlehem. There are also sculptures of the Virgin and Child and of the Kings associated with the birth of Christ. The carving of many fleur-di-lis on one particular pillar, the Apprentice Pillar, and on the cusp of the roof suggests masons from France may have been responsible for a portion of the work inside Rosslyn. The fleur-di-lis is symbolic of the iris and the lily, both of which are said to represent the Virgin Mary. The arched roof is made of stone that is decorated by five-pointed stars, flowers, roses and a dove with an olive branch. Some of the stone carvings are of cacti and corn. Because of these carvings, some historians assert that Henry St. Clair, grandfather of the St. Clair who began the chapel, had crossed the Atlantic sometime around 1400 and returned with plants not then known in Britain and Europe.

Henry St. Clair also had strong ties to the Knights Templar, the warrior knights who allegedly protected pilgrims traveling from Britain and Europe to Jerusalem. Legend has it that some of these knights lie in full battle armor in a huge sealed crypt beneath the chapel. The Knights became at one time very rich

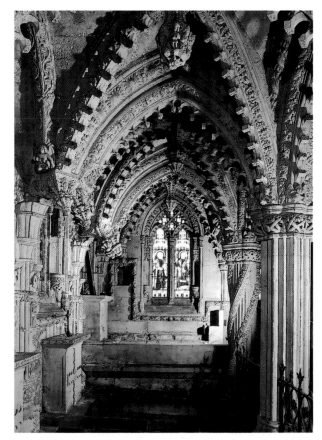

© Antonia Reeve/Rosslyn Chapel Trust

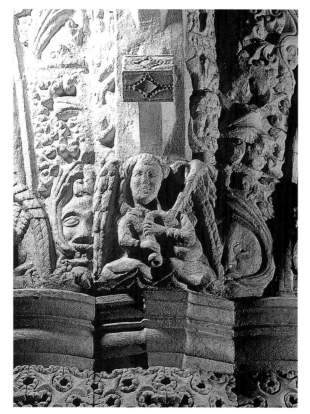

Angel with bagpipes (detail)
© Antonia Reeve/Rosslyn Chapel Trust

greatest examples of medieval architecture in Great Britain.

The final chapters of *The Da Vinci Code* take place at Rosslyn Chapel. Brown points out that the structure is engraved with symbols from the Jewish, Christian, Egyptian, Masonic and pagan traditions. According to Brown, its geographic coordinates fall on the north-south meridian, or Rose Line, that is considered Britain's central longitudinal line.

Langdon and Sophie, primary characters in the novel, are led there in search of the Grail. Brown goes into detail in these pages to explain the history of the chapel and to describe the art and symbols found within it. One such symbol is the Star of David, which is described in *The Da Vinci Code* as the ancient symbols for male and female fused as one. The upward pointing triangle (the blade) over-laying the downward pointing triangle (the chalice) form the symbol known as the Star of David.

He references a chamber that allegedly lies beneath the chapel that may indeed hold the Holy Grail, which some say was hidden there centuries before by the Knights Templar. In the novel, Sophie recognizes the building and symbols and realizes she has visited the site before with her grandfather. The loose ends of the plot are brought together with Sophie realizing that the docent at the chapel and his grandmother (who, in the novel, heads the Rosslyn Trust), are her family—her brother and her grandmother. The reader is left to make his or her own determination regarding the Grail. What is it? A chalice, lost documents, a hidden history or the bones of Mary Magdalene? Where is it hidden? Is it in the chamber beneath Rosslyn, or was it returned to France? (Pages 432–449.)

and powerful and some believe that their treasure is also buried in the crypt beneath the chapel. Those who support this theory claim that the floor plan is a replica of the floor plan of Herod's temple. Some go so far as to propose that the Holy Grail lies there. Many attempts have been made in modern times to access the crypt, but none have been successful.

Regardless of whether one believes the various legends associated with Rosslyn Chapel, there is no dispute among experts that the building is one of the

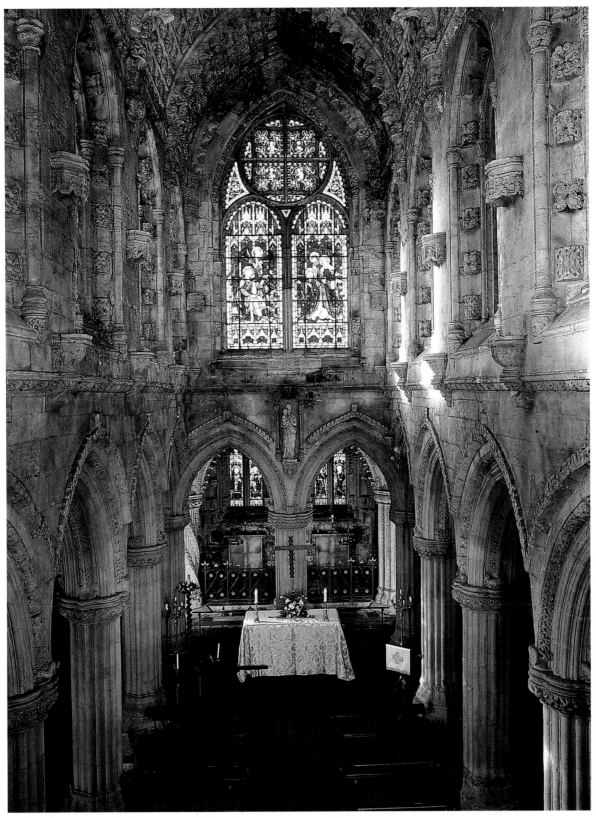

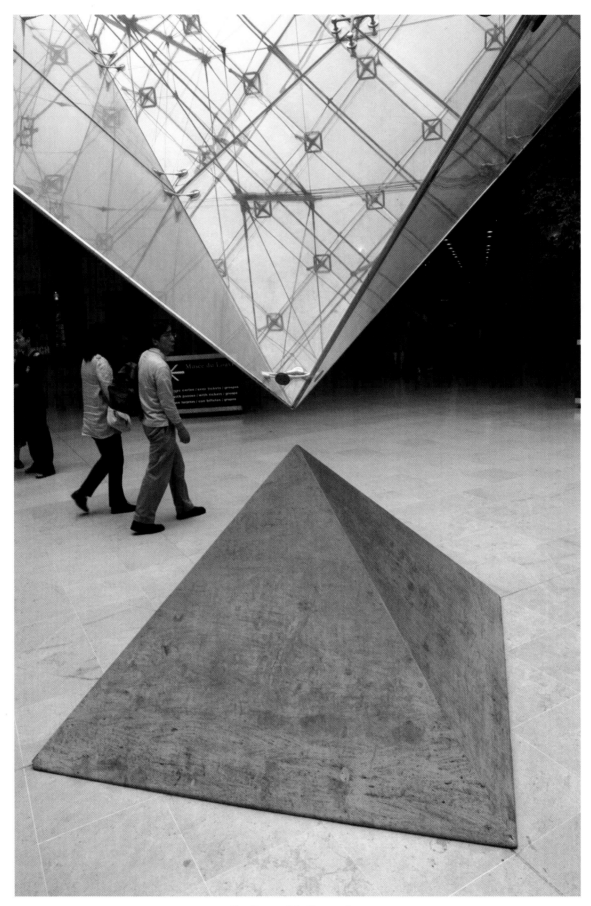

La Pyramide Inversée.
Musée du Louvre, Paris, France
Stuart Isett Photography, 2004

La Pyramide Inversée

Near the Louvre is the Carrousel du Louvre. At road level it has been redesigned and it includes the inverted pyramid, *la pyramide inversée,* referred to in *The Da Vinci Code.* In the epilogue, Dan Brown provides readers an opportunity to believe that there was a hidden agenda in the renovation of the Louvre—creating a safe resting place for the Holy Grail. According to our protagonist's interpretation, the *pyramide inversée* may represent the Chalice or Holy Grail. The miniature pyramid within the underground structure that comes up to meet it is the apex of a larger "pyramidical vault submerged below like a hidden chamber," possibly representing the blade. Are the Magdalene and her story buried below? (Pages 452–454.)

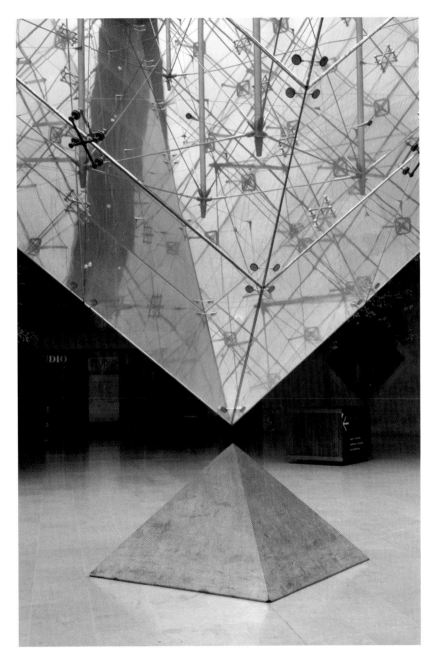

La Pyramide Inversée.
Musée du Louvre, Paris, France
Stuart Isett Photography, 2004

Bibliography

Web sites

America, the National Catholic Weekly: www.americanmagazine.org.

Atlantis Rising Magazine, Ancient Mysteries, Future Science, Unexplained Anomalies: www.atlantisrising.com.

Bulfinch's Mythology: www.bulfinch.org.

Catholic Online Forum: http://forum.catholic.org.

The Christian Science Monitor: http://search.csmonitor.com.

Encyclopedia.com: www.encyclopedia.com.

Encyclopedia Mythica, an Encyclopedia on Mythology, Folklore, and Legend: www.pantheon.org.

Esoteric Theological Seminary: http://northernway.org.

Frommer's (travel): www.frommers.com.

Galinsky, People Enjoying Buildings Worldwide: www.galinsky.com.

Grand Encampment of Knights Templar of the United States of America: www.knightstemplar.org.

The Great Buildings Collection: www.greatbuildings.com.

Hellenism Network: www.hellenism.net.

The History of the Louvre: www.louvre.fr/anglais/palais/siecles.htm.

in2greece: www.in2greece.com.

Island of Freedom: www.island-of-freedom.com.

JewishEncyclopedia.com: www.jewishencyclopedia.com.

Loggia, Exploring the Arts and Humanities: www.loggia.com.

Mark Harden's Artchive: www.artchive.com.

Metropole Paris: www.metropoleparis.com.

Mythweb: www.mythweb.com.

New Advent: www.newadvent.org.

Old and Sold, Antiques Auction & Marketplace: www.oldandsold.com.

Olde Knights Templar & Rosslyn Chapel: www.kt-scotland.fsnet.co.uk/rosslyn.htm.

Olga's Gallery: www.abcgallery.com.

Ontario Consultants on Religious Tolerance: www.religioustolerance.org.

Opus Dei: www.opusdei.org.

The Palace at the Louvre: www.louvre.fr/anglais/palais/palais.htm.

Paris Digest, the Paris Internet City Guide and Portal: www.parisdigest.com.

The Paris Pages: www.paris.org.

Pre-Tribulation Planning for a Post-Tribulation Rapture: www.tribwatch.com.

The Pyramid at the Louvre: www.louvre.fr/anglais/palais/grandlou/pyramide.htm.

The Rick A. Ross Institute for the Study of Destructive Cults, Controversial Groups and

Movements: www.rickross.com.

Rosslyn Chapel (official Web site): www.rosslyn-chapel.com.

Rosslyn Chapel Trust: www.rosslynchapel.org.uk

Templar History Magazine: www.templarhistory.com.

Temple Church, London: www.templechurch.com.

University of Rochester, River Campus Libraries: www.lib.rochester.edu.

U.S.A. the Republic, How You Lost It: www.usa-the-republic.com.

A View on Cities: www.aviewoncities.com.

Web Gallery of Art: www.kfki.hu/~arthp/html.

Books

Janson, H. W. *History of Art.* New York: Harry N. Abrams, Inc., 1967.

Kleiner, Fred S., Christin J. Mamiya, and Richard G. Tansey. *Gardner's ART through the Ages.* Orlando, FL: Harcourt College Publishers, 2001.

Paoletti, John T., and Gary M. Radke. *Art in Renaissance Italy.* New York: Prentice-Hall, Inc., 1997.

Preble, Duane, and Sarah Preble. *Artforms: An Introduction to the Visual Arts.* 5th ed. New York: HarperCollins College Publishers, 1994.

Stokstad, Marilyn. *Art History.* Rev ed., Vol. 1 and Vol. 2. In collaboration with Bradford R. Collins, and contributions by Stephen Addiss, Chu-ting Li, Marilyn M. Rhie, and Christopher D. Roy. New York: Harry N. Abrams, Inc., 1999.

Index

A

Adonis, myths about, 51
Adonis, Venus and (Titian), 50
Adoration of the Magi (da Vinci), 46–47
Amon, 36
Aphrodite, 51
Arc di Triomphe du Carrousel, 5

B

Baphomet, 15, 59
Baptism of Christ (Verrocchio), 3
Bois de Boulogne, 42–43

C

Christianity
 da Vinci's beliefs and practices, 3, 19
 pagan symbols, 27, 49
 pentagram use, 15
 Shekinah's influence, 58
cornucopia, 59

D

da Vinci, Leonardo. *See* Leonardo da Vinci
Delacroix, 23
Dionysus, myths about, 49
Dionysus II (Stevenson), 49
Dionysus in a Boat With a Vine (Exekias), 48
Disney, Walt, 57

E

Egyptian gods and goddesses
 Amon, 36
 Horus, 27–29, 37, 39
 Isis, 27, 29, 37–39
 Osiris, 26–27, 29, 37, 39
Escriva de Balanguer, Jose-maria, 9
Exekias, *Dionysus in a Boat With a Vine,* 48

F

feminine, sacred, 19, 55, 57
Freemasons, 45

G

The Glass Pyramid (Pei), 11–12
Greek mythology
 Adonis, 50–51
 Dionysus, 48–49

H

Holy Grail
 clues in da Vinci's paintings, 47
 in *The Last Supper,* 53
 legend of, 54
 under *la pyramide inversée,* 67
 rose as symbol of, 31
 at Rosslyn Chapel, 64
Horus, 27–29, 37, 39

I

Isis, 27, 29, 37–39

J

Jardin des Tuileries, 5–6
Jesus Christ, 53–55
John Paul II, 9
Joseph of Arimathea, 55

K

Knights Templar, 45, 55, 59, 61, 64

L

The Last Supper (da Vinci), 3, 47, 52–54, 55
La Tour, Georges de, *The Penitent Magdalen,* 56–57
Leonardo da Vinci
 Adoration of the Magi, 46–47
 Holy Grail clues, 47
 The Last Supper, 3, 47, 52–54, 55
 life of, 3
 Madonna of the Rocks, 38, 40–41, 47
 Mona Lisa, 3, 34–35, 47
 religious practices, 3, 19
 Self Portrait, 2
 Virgin of the Rocks, 3, 40–41, 47
 Vitruvian Man, 18–19

The Little Mermaid, 57
London, Temple Church, 60–61
Louis XVI, 5
The Louvre
 galleries, 13
 The Glass Pyramid (Pei), 11–12
 Madonna of the Rocks (da Vinci), 41
 Mona Lisa (da Vinci), 34–35
 Venus de Milo, 16–17

M

Madonna of the Rocks (da Vinci), 41, 47
Mary Magdalene, 54, 55
Meridien, Paris, 31
Midas, 49
Mitterand, Francois, 11
Mona Lisa (da Vinci), 3, 34–35, 47

n

Napoléon Bonaparte, 5, 21, 43
Notre Dame Cathedral, 20–22

O

Opus Dei, 8–9
Osiris, 26–27, 29, 37, 39

p

pagan symbols, use of by Christians, 27, 49
Paris Meridien, 31
Pei, Ieoh Ming, 11–12
The Penitent Magdalen (de la Tour), 56–57
pentacle, 15
pentagram, 15
Persephone, 51
Priory of Sion, 9, 45, 55
Pyramid, The Glass (Pei), 11–12
la pyramide inversée, 66–67

R

Roman Catholic Church, 9, 45, 58
Rose Line, 30–33, 64
Rosslyn Chapel, 30, 62–65

S

sacred feminine, 19, 54, 57
Saint-Sulpice, Church of, 23–25, 30
Sangreal documents, 54
Satanists, 15
Self Portrait (da Vinci), 2
Shekinah, 58
St. Clair, Henry, 63–64
Star of David, 64
Stevenson, Harold, *Dionysus II,* 49

T

Templars, 45, 55, 59, 61, 64
Temple Church, 60–61
Titian, *Venus and Adonis,* 50
Tuileries Palace, 5–6

V

Venus and Adonis (Titian), 50
Venus de Milo, 16–17
Verrocchio, Andrea del, 3
Vinci, Leonardo da. *See* Leonardo da Vinci
Virgin of the Rocks (da Vinci), 3, 40–41
Vitruvian Man (da Vinci), 18–19

Z

Zeus, 49